LIKE THE SEA

Dancing with Mary Glass

CAROL MAVOR

FORDHAM UNIVERSITY PRESS NEW YORK 2025

Copyright © 2025 Fordham University Press

All rights reserved. No part of this publication may be reproduced, stored in a retrieval system, or transmitted in any form or by any means—electronic, mechanical, photocopy, recording, or any other—except for brief quotations in printed reviews, without the prior permission of the publisher.

Fordham University Press has no responsibility for the persistence or accuracy of URLs for external or third-party Internet websites referred to in this publication and does not guarantee that any content on such websites is, or will remain, accurate or appropriate.

Fordham University Press also publishes its books in a variety of electronic formats. Some content that appears in print may not be available in electronic books.

Visit us online at www.fordhampress.com.

For EU safety / GPSR concerns: Mare Nostrum Group B.V., Mauritskade 21D, 1091 GC Amsterdam, The Netherlands. gpsr@mare-nostrum.co.uk

Library of Congress Cataloging-in-Publication Data available online at https://catalog.loc.gov.

Printed in the United States of America

Designed and typeset in Merope by
Amy Ruth Buchanan/3rd sister design

27 26 25 5 4 3 2 1

First edition

for Mary

CONTENTS

Preface xiii

I Like Mary Glass 1
Dance Is Our First Art Form 2
Under a Nearly Cloudless Sky 4
A Caul Should Be Kept for Life 9
The Defeated Owl Spirit 12
Lake Tahoe Never Blinks 13
Alone in the Shell 15
Taking Three Hundred Years to Grow into an Oak Tree 19
A Desire to Steal 21
Like Anything That Feels Really, Really Good 25
Until They Are Lost 28
The Pacific Is Made of the Blues of Mary's Dream of a Glass House 34
Like the Jellyfish That Wash Up on the Beach That She Sometimes Accidentally Steps On 35
Fairytale Modernism 38
Appetite 43
We've Danced with Ruth and Merce on Anna's Redwood Deck 44
At Last, They Come Out—Explosively but Gently 45
Heart Beating under Bark 50
Mary Does Not Love Aaron 54
I Could See That They Were Running and Skipping and To Me It Was Dancing 56
Her Voice Is Voluptuous, Almost Masculine 58
Even Though She Is a Vegetarian 62
My Excited Pupils Enlarged / M. XXX 64

The Secret That Was Melody's Alone 67

In You 69

Honey from Mr. Larkin's Bees 70

Like the Noses of Rabbits 71

The Stars Are Aligned 72

Eyes Washed in Tears 73

Girlfriends Who Traveled to the Other Side 75

Mary Cannot Imagine That It Is Anything Serious 80

Imagination Is a Killer 82

The Nature of Grief 84

The Same Thing 85

Mary's Companion Lover 88

He Will Lose Nico 89

Into Her Skirt Pocket 90

To Wait Is to Love 92

Like a Drug in Eliza's Veins 94

Pulled Out by Coda's Hot Light 99

To Eat Is to Steal 101

To Love Is to Wait 104

Dance That Is All 105

Time to Dance 106

A Scale Model of Vietnam 108

To Nourish 109

The Halprins Are Friends of Godunova 110

And No Birds Sing 111

A Big Newfoundland Dog Named Carlo 112

Mother of Black Dance 114

Big, Drooling, Shedding Beast 115

The Same Deep Thought 117

The Knitting Is So Tender 120

Down Haight Street 121

No Strings 122

Yucatecos Like Me Speak Maya 127

Visible Stars, Even When the Sun Is Up 132

Something Begins 133

Mary Sees a Baby's Face in the Waves 136

Curved as a Dolphin Bone Held in the Sea 138

Eliza Says Her Sorrow Is So Great That the Mountains Changed Places and Began to Leak Milk 139

Ocean's Time 141

Blood Everywhere 144

Nothing Inside of Mary 145

No Song 146

Is This What You Wanted? 147

That Dark Involvement with Blood and Birth and Death 148

That White Feather Floating on Top of the Sea 149

What Happened? 150

Would Something Else Have Happened? 153

Until It Dissolves in One's Mouth 154

The Heart Is a Safe Place / Especially if It Belongs to a Beloved Sister 156

As She Fingers the Breath Holes of the Abalone Shell Again 160

And Someone Turned the Moon Off 162

To Disappear 163

Like the Sea 164

Afterwor(l)d 167

Acknowledgments 173
Illustration Credits 175
Notes 179

PREFACE

I call out to Mary Glass.

Mary your story sent me dancing, swimming, riding, jumping, floating, eating, birthing, drowning, reeling, tippy-toe, tippy-toe, round and round we all fall down. And here is your story as I feel it.

Mary you are my urine, my heat, my madness, my sleep, my sea, my me.

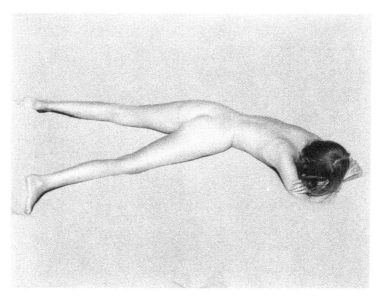

Like heat from the rays of the sun while lying naked on the beach.

I LIKE MARY GLASS

Like the surprise of finding a sea anemone in a tidepool, the size and color of a green chrysanthemum: at first fluorescing then closing unexpectedly.

Like finding sand dollars in the wet sand.

Like giant kelp wrapping around your ankles — treasuring your fingertips — snagging you unawares. Sticky. Wet. Prickly. Ribbons of underwater crêpe flypaper.

Like heat from the rays of the sun while lying naked on the beach: eyes closed; ears open and filled with the sound of the sea.

Like the arms of a lone windswept Monterey cypress atop a rocky cliff at Land's End in Golden Gate Park reaching out to the sea.

I like Mary Glass.

DANCE IS OUR FIRST ART FORM

Mary can no longer kick, turn, extend, curl up, take a bow.
 There seems to be less water.
 There is less space.
 It has only been a week since Mary took her astonishing turn, in preparation for her exit.
 Head down.
 Chin tucked to her chest.
 A disappearing act.
 Seen by no one.
 Dance is our first art form.

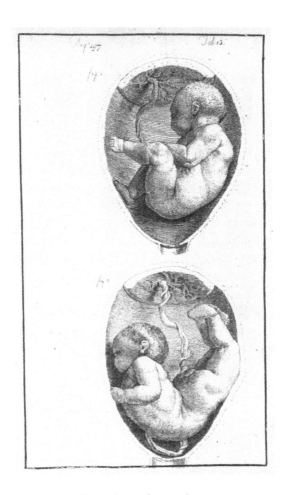

Dance is our first art form.

Here she comes.

Mary Glass is being born, just ten months after her sister Melody—in San Francisco, California.

The day is August 27, 1946.

The sea is mostly smooth. Each infrequent wave—softly collects itself, pronouncing a small "hello." To which Mary's mother, Henrietta Glass, whispers back with a tone of maritime politeness, "Hello, you." The waves and Mary are holding back: they are taking their time. Barely making any waves at all.

Then, rather unexpectedly, one by one, each little wave begins to get a little bigger. As the they grow, small convulsions of real pain begin to radiate between Mother's legs. Like short, sharp muscle spasms at the sole of your foot, when you are swimming and you get a cramp. Only the pain is at the base of Mother's pelvis and rectum. "Oh," Mother says, with each surge, as politely as she can.

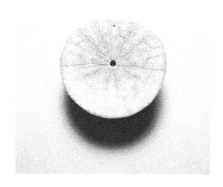

Mother's sand-dollar cervix is beginning
to widen its mouth hole larger.

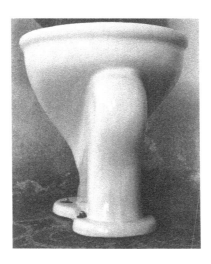

Into this porcelain nautilus, her vagina spits out
a mucousy, blood-tinged sea slug . . .

Hours later the waves are bigger, stowing baby bat rays with venomous barbed spines at the base of their long tails. Mother's sand-dollar cervix is beginning to widen its mouth hole larger.

Mother feels ill and slowly manages her way to the toilet: bleached and scrubbed of the cephalopod, prepared for some unknown blessing. A pearlized orifice, with a missing tongue for unspeaking. She sits on its coldness with hot sweaty thighs. Into this porcelain nautilus, her vagina spits out a mucousy, blood-tinged sea slug, into a yellow tidepool of urine.

Mother and Mary are on their way now. Closer. Closer. The waves come. And each one a new height. Spectacular unimaginable heights of pain. Mother waits for the fall. For the flat ocean. Never long enough. Mother vomits from the pain. That's new, Mother thinks. But only for a second, for here comes another wave.

Mother shits in the bed.

Collect and fall.

Collect and fall.

That is all.

Collect and fall.

That is all.

Mother's uterus heaves violently and collectively for all the sorrows of the sea, and then naively renews—as if the world were turning the right way. The relief is too brief.

Collect and fall.

Collect and fall.

That is all.

Collect and fall.

That is all.

The trickle of their shared blood continues to make its way through Mary's umbilical vein to Mary's staccato heart. Mother's bones make audible branch-cracking sounds. Mary's bones are silent and soft like green saplings.

Up there, at the top of the huge wave, Mother is on the borderline between dreams and reality. Mother sees Father on the beach. "Theo," she whispers. "Theo," she cries. Father cannot hear her. Father cannot see her. Father is part of a real dream. An inverted moving image. An unreachable husband in the camera obscura of Mother's mind.

Mother reaches the shore, becomes the shore, shoving the waves back.

Get back.

Get back from my baby.

Mary forces her way through to the very last: the soft part of Mother's birth canal. Mary is a log being dragged over a pebble beach. And out to the sea.

From between Mother's open legs, the amniotic sac emerges quickly—yet time is held—like a giant breath of air. With great tidal force, Mother's contracting muscles push Mary out.

Despite the pressure and the speed of Mary's descent, Mary is very careful not to tear the membrane with her infant fingernails and toenails. Mary remains inside the unharmed sac—the theater of her first dance.

The doctor's rubber-gloved hand catches Mary in this clear Saran-

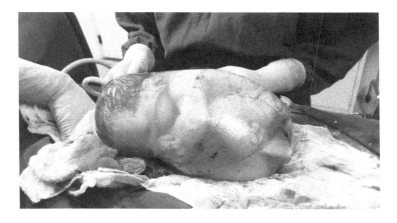

Mary remains inside the unharmed sac—
the theater of her first dance.

wrap amniotic sac. Filled with unbroken membrane waters. Mary's peek-a-boo egg. Mary's chrysalis.

Catch the ball.

Catch the baby.

Catch the meaning.

Catch Mary.

The image of Mary in the sac is stunning.

The scene is the transparent, veined, botanical-animal-dandelion ball, glassine home, which houses a little naked man and a little naked woman in Hieronymus Bosch's *The Garden of Earthly Delights*. Only Mary is all alone.

Mary was born "en-caul."

This is very rare.

Very lucky.

Sailors once cherished cauls as amulets to prevent themselves from drowning—purchasing them at very dear prices. To have the caul meant you could survive in water like an unborn infant. The caul could magically keep the sailor full of breath, as if there were an invisible umbilical cord delivering oxygen from his lost or faraway mother.

In French *la mer* (the sea) and *la mère* (the mother) are homonyms.

Peering into Mary's glass egg, still soft at the end of the glass blower's straw, you can see the pale blue-blue twisted rubber licorice umbilical cord wrapped around Mary's face, just below her still-closed, long-slit-eyes. Mary is not ready to open her eyes, not yet.

Gloved fingers gently tear the slimy casing. A sea of water is gently released. "Thank you," whispers the doctor in awe as he pulls the caul away from Mary's scrunched face and little body, so skinny and chubby at once.

A little selkie being robbed of her seal skin.

No longer in a cupboard of two hearts.

Mary thumps alone.

She calls for Mother.

Mary's first song.

A call of vowels.

Mother is exhausted.

Mother is on the beach asleep.

Dreaming.

Full of pleasure.

Mary rests on Mother.

Mother bestows her heat onto Mary.

Like sun-soaked sand on the seashore.

As if it were 11:00 a.m. on a warm day, under a nearly cloudless sky.

A CAUL SHOULD BE KEPT FOR LIFE

Mother saved the caul that Mary was born with and pressed it in her diary: as if a corsage from Mother's first high-school dance.

Those born with the caul who fail to be buried with it are believed to remain on earth as endlessly looking for their lost caul.

Like a lost sister.

Like a lost lover.

Like a lost mother.

There in one of Mother's "books" (part scrapbook, part diary, part herbarium, part field notes, part dream journal, part recipe book) is Mary's caul: right there in the middle—a place of neither beginning nor end.

Pressed like dried seaweed that had once been wet with life.

Pressed like a memory.

Pressed like an urge to push.

It is there with Mary's birth announcement from the *San Francisco Chronicle*—"Mr. and Mrs. Theophilus Glass, 1117 Sunset Way, girl, Mary Josephine, August 27."

And a lock of Mary's light-brown baby hair.

And the tiny baby bracelet that Mary wore at the hospital, which spells out "MARY GLASS" with a string of beads: ivory-white, powder-blue, and carnation-pink.

Mary's ephemeral caul is there along with an old newspaper clipping from 1920, in which Grandmother is naked with two other young Marion Morgan dancers. All three nymphs are gazing at themselves in a pool of water made lovelier by the flowering Nymphaea, which reflect their naked bodies from another time.

Girl-Narcissi.

Shockingly printed in all their soft-focus nudity in the *Los Angeles Times*.

Dancers who wrapped seaweed around their naked bodies.

Dancers who held seashells to their ears as they leaped naked

through the air, listening to the sea as they flew. These young women neither knew nor cared that the sound they heard was not the sea—that it was actually the reverberation of their own blood pounding through their heart—splashing, humming, rushing, coming inside their ears.

They were the sea.

To be born with the caul is highly auspicious.

Especially if your grandmother danced nude with the Marion Morgan Dancers.

Especially if you were born to a family of California vegetarians in 1946.

Mother and Father met while working at a vegetarian raw-food cafeteria called the Eutropheon (which the owners claimed was Greek for "uncooked" or "good nourishment").

At their wedding, Father read a strange and sensual poem by the French surrealist André Breton entitled "Free Union":

> *My wife with the armpits of martens and beech fruit*
> *And Midsummer Night*
> *That are hedges of privet and resting places for sea snails*
> *Whose arms are of sea foam and a landlocked sea . . .*

As they exited the ceremony, the guests tossed birdseed, rather than rice, blessing Mother and Father with happiness.

Tears in their eyes.

Smiles wide.

Everything is possible.

Father would become a professor at UC Berkeley, specializing in paintings from the Indian walled-in city of Jodhpur—where the old houses are painted blue, appearing like a mirage in the Thar Desert—indigo, turquoise, ultramarine, violet. The reasoning behind the blue is as elusive as its color. Perhaps because . . .

—blue cools, like being underwater

- —there was a penchant for indigo
- —copper sulphate, used to repel termites, turned the walls blue
- —the Brahmins used it on their houses for class distinction

Blue skies and the blue ocean are an "illusion" (reflected light), painted blue is "real" (absorbed light).

When Mother became a mother, she continued her art of making small "nothings" out of the natural world—vessels out of a wasp nests—or translucent skeletal leaves—or seaweed bulbs.

Found things.

Or, as Mother would say, things that found her when she did not know what she was looking for.

Ephemeral gifts.

To keep for life.

A caul should be kept for life.

THE DEFEATED OWL SPIRIT

To grow up in San Francisco means a childhood of natural wonders.

The Pacific Ocean at your feet.

Redwood trees waving at the Pacific along the coast of Northern California.

The largest trees in the world, the giant sequoia, grow naturally along the western slopes of the Sierra Nevada in nearby central California. Towering overhead, the *Sequoiadendron giganteum* are fairytale giants.

Father and Mother once took the Girls to see one of the most famous sequoias of all time—the Wawona Tree in Yosemite's Mariposa Grove. The name Wawona is believed to be an onomatopoetic word representing the hoot of an owl in the Miwok tongue: "who-who'nau." The owl is the guardian spirit of the sequoia.

An enormous tunnel was cut through Wawona's trunk in 1881 for the passage of horse-drawn carriages. The sight of the ravaged tree deeply disturbed Mary. Father photographed Melody standing in the middle of the tunnel. Mary refused.

Wawona fell in 1969, when she was 2,100 years old, 234 feet high, and 26 feet in diameter. It may have been the weight of the snow in her heavily burdened branches, along with the loss of strength caused by the savage tunnel—along with too many clicks of the camera, causing Wawona to lose a thin layer of bark, like layers of skin, with each photo taken. "Wawona, Wawona, Wawona" cries the defeated owl spirit.

Lake Tahoe is a four-hour drive from San Francisco.

Cradled by the Sierras—nuzzled in a basin of redwoods and pines—Lake Tahoe is the sixteenth deepest lake in the world, the second deepest in the United States.

Mary is but three years old. Father is teaching her to ski at Sugar Bowl, a winter resort in Lake Tahoe, California. Mary stares at the giant mountain, glistening in the sun like sugar.

Melody learned to ski last year. As a brave and accomplished skier, Melody is there to show her younger sister the way.

Mary does not have proper ski boots. Father is having trouble securing her poppy-red rubber galoshes onto Mary's small Sierra-sky-blue wooden skis with cumbersome cable bindings. Mary stands frozen—encumbered by too-big mittens—a too-big puffy jacket—and two pairs of long johns under Melody's old ski pants.

Father shows Mary how to walk up a hill in skis—poles digging in—front tips wide open—backs touching together—click-clacking with the slow climb. Mary and Father leave behind huge Ice Age bird tracks. Mary whines from the cold, but she will not cry in front of Melody.

Father takes Mary up a big hill on the rope tow. Mary is secured between Father's legs; she clutches his big knees with her mittened hands as tightly as she can. A perfect fit. Mary peers out from the two Father knees. Mary smiles while being pulled up the hill with ease and steady speed. Under Mary's skis, the snow feels smooth, white, pure.

Father hangs on tightly to the rope. Mary hangs on tightly to Father's knees. Up ahead of them, Melody hangs on tightly to the rope: proud to be on her own. Melody is wearing real ski boots, made of leather, two layers of lacing: one inside, one outside. Father does the laces for her. They are difficult.

Finally, Father and Mary are going down the bright white hill, with Mary still held between Father's legs. People are turning their heads to see the spectacle of the two of them: zooming, flying, grinning, brave. Melody whizzes past Mary and Father—laughing and singing "My Favorite Things." She loves the part about snowflakes that stay on your nose and eyelashes—but she does not know what schnitzel with noodles is.

> A high-altitude lake.
> Famous for its deep blues.
> *A blue eye staring back at its beloved blue sky.*
> A behemoth blue eye in love with the sky.
> For about two million years.
> An ancient eye still colored brand-new blue.
> Wide-eyed and star-struck.
> Lake Tahoe never blinks.

Mary is five years old.

Father is teaching her to tie the laces on her brand-new saddle shoes. No more "one two, buckle my shoe." Before her are a pair of two-tone oxfords—cream-colored, with Crayola-crayon-mahogany-brown saddle-shaped accents. Thick, clean, white laces. Mary stares at these institutional shoes. They are repugnant. But Mary loves the promise of their newness.

Father and Mary are sitting together on the hardwood floor of Mary's bedroom. Father holds one of Mary's new shoes: loosens its laces widely, before tenderly inviting her small foot swathed in a white-cotton bobby sock to slip inside. Father eases her heel down with a shiny silver-metal shoehorn, just like the one at the Stride-Rite children's shoe store.

Father recites the bunny ears poem to teach Mary's little hands how to tie a shoe. As he quietly chants, Father's big hands work with Mary's pint-size hands to tenderly, awkwardly (yet successfully) tie the laces of one of her promising (yet repugnant) new school shoes.

> Bunny ears, bunny ears,
> playing by a tree,
> crisscrossed the tree,
> trying to catch me.
> Bunny ears, bunny ears,
> jumped into the hole,
> popped out the other side,
> beautiful and bold.

Sing-song choreography for their slow dancing hands.

With their tongues ready and waiting, Mary's saddle oxfords will take her away from the Mother and Father—will transport Mary to another country—the dystopian land of school.

Stressful line formation. "Everyone straight. Everyone silent!"

Stressful ugly physical-education uniforms.
Stressful cafeteria lunches.
Stressful bathroom passes, constructed out of a plank of wood, so as to be shamefully visible and impossible to lose.
In sum: the land of not home.

Melody has already begun the journey.
"Childhood is the true meaning of life, the apex of our existence . . . the rest of life is a slow journey away from it."

First day of kindergarten—Mary's coltish legs, tan from the months of June, July, and August, sport her clumsy shoes—too stiff, too big. Mary wears a red-cotton sleeveless dress appliqued with "A B C," over a crisp white-cotton short-sleeved blouse with mother-of-pearl buttons and a Peter Pan collar. The dress is snug at the bodice. Its skirt is fully gathered and bursts from the fitted waist like a violet-pink-red peony. The seaside of Mary's thighs, warm with the last of summer, are barely hidden by the waves of her ample but short skirt, as was the style in those days. Mary's child-eyes are very big. Mary's hair is very short. Mary's pixie-cut hair is like Mia Farrow's in *Rosemary's Baby*—a film about terror and paranoia, about women's liberation, birth, the occult and Catholicism. But that 1968 film was not made when Mary was five. When Mary was so new and clean. When Mary was a bruiseless child.

Mary is so new and clean.
 A real child.
 On her way.
 Everything is happening for the first time.
 At school Mary boasts: Grandmother skipped nude on the beach with the Marion Morgan Dancers—she appeared naked in the *Los Angeles Times*. "Go look it up at the public library!" Mary shouts to them. "Father goes to India to study paintings made in a city called Jodhpur,

where all houses are painted as blue as the sea on a hot summer day. I have never tasted meat before."

"My parents met at the Eutropheon—a vegetarian raw food cafeteria in Los Angeles. In Greek, *eutropheon* means 'good nutrition.'"

Mary is pure.

Mary has no need to distinguish between lies and truths.

Even though she is telling the truth.

At recess, Mary and Aaron will go into the woods, beyond the asphalt playground, where fir trees have been planted in neat rows.

"There's a caterpillar on your neck," Aaron whispers to Mary.

Aaron touches it gently.

Aaron is breathing heavily on Mary's neck.

In a field beyond the woods are two rabbits—little brown ones sitting in a field of strawberries, flowering, but no fruit.

Not yet.

Mary and Aaron do not see the rabbits.

They are them.

The woods smell of . . .

- —bitter-orange peel
- —rotty-weedy-green forest
- —pear-clean
- —soapy-spicy-powdery-mossy-needle arboreal
- —juniper
- —rose-medicinal
- —amber-herbal
- —and of Aaron
- —fresh and sweaty
- —like young garlic
- —like a tender smooth white bulb giving way to new-green
- —his freckles like burnt toast

Mary does not have her first ballet shoes. Not yet. A photograph of her, as a young woman, naked, save for her dirty and worn ballet shoes, sitting in a chair, has not been taken. Will never be taken. Will reside in the camera obscura of Mary's mind.

In the picture never taken, Mary's hair falls forward, covering her face in profile. The walls are like iridescent mother-of-pearl. As if Mary is within an abalone shell made of soaped mirror. Mary is a very small woman. You can see Mary's smallness. Even her voice will remain small once grown.

Alone in the shell.

TAKING THREE HUNDRED YEARS TO GROW INTO AN OAK TREE

It troubled me as once I was —

For I was once a Child —

Concluding how an Atom — fell —

—Emily Dickinson

"Guess what," Father might say while picking up a pebble. "Inside a pebble, millions and millions of little atoms are dancing."

"See that dog wagging its tail?"—Father says. "There are dancing atoms in there too."

As Melody and Mary play Cat's Cradle—crossing their strings with tiny fingers—they hear Father say: "You two think your fingers are solid—not moving, except when you choose to move them—yet your fingers are made of millions of dancing atoms. Think of everything in the world as dancing atoms, as always moving."

As children playing face-to-face, Melody are Mary are connected by a Cat's Cradle string. But even when not playing Cat's Cradle, they are bound together by invisible threads. Together, their hearts feel safe. Heart to heart.

For Mary, even words are dancing atoms.

When Mary hears "bird," she feels . . .

- —the movement of the fluttering of wings
- —the hopping of feet
- —her body pressing, kneading, beating
- —the dropping of eggs
- —the releasing of the body into a thick blanket of feathered fleshiness

- —the smoothness and resilience of fertilized eggshells beneath her
- —leaves, sticks, moss, stems, strings
- —on her bottom and thighs
- —warmness keeping

When Mary hears "acorn," she feels . . .

- —a fall from a tree
- —sitting stone-still on the ground with a large group of other acorns
- —the shock of being chosen by a child who grabs her entire being
- —being shoved into a dark pocket
- —the strange tickly feeling of being eaten from the inside
- —the elongated snout of a nut weevil
- —the resulting lightness of being
- —the stretching out of time
- —taking three hundred years to grow into an oak tree

Mary and Aaron are eight.

That's Aaron jumping into the sea.

Can you see him in your mind's eye?

It is Indian Summer.

"On a day like today," Mother explains, "it is quite hot, as if we were in India."

Mary and Aaron are at a beach on Mendocino's coast. The children call it "Glass Beach." The meadows of dairy farms gently pull away from its faraway edges.

Mary and Aaron are innocent and shameless, yet they are not.

They are no longer naked children.

Aaron is in red swim trunks, with a long string tied at the waist.

Mary is in a two-piece navy-blue bathing suit with a short white pleated skirt covering her swimsuit bottoms.

Melody is wearing a pair of turquoise-blue terrycloth shorts and a Mexican-embroidered peasant blouse.

Along the shore, the water shimmers . . .

- —light blue
- —petal-pale-silver-rose violet
- —sea-foam white
- —cobalt-blue
- —sand-champagne

Further out are tall waves that rise and fall—cerulean steps ascending from the sea—leading up to lapis-lazuli doors and indigo houses.

The Pacific is Jodhpur.

The Pacific is a city whose painted waters of copper-sulfate blues cool the heat of the day.

Aaron takes a head dive into the sea. Aaron's golden-sienna hair, more golden with summer, is shorn. The sun licks his heels before

he plunges into the icy water of Northern California's Pacific. Aaron's body shrinks a wee bit in anticipation of the cold that is about ready to slap him. He turns a little Shiva blue.

Mother has brought the three children to their "Glass Beach" to collect things—to look for pebbles of broken glass, polished round by the sea. Cobalt blue stones from Milk of Magnesia, Vicks VapoRub, Noxzema, Nivea, and Bromo-Seltzer bottles. Rubies from the sea-beaten hearts of the tail lights of automobiles, traffic light lenses, and Anchor Hocking beer bottles. Brown glass from Clorox Bleach bottles. Leaf-green glass from old inkwell bottles. Rare pinks, lavenders, and purples from perfume bottles. Clear glass from canning jars and the lenses of eyeglasses.

And there are other things, ugly things—rusted, tarnished, broken, familiar and unknown things—batteries, springs, magical-looking spark plugs, piston rings, oven knobs that look brand new, rough and pointy screws of all sizes, banged up spoons, forks with bent tines.

Ever since Fort Bragg was destroyed by the 1906 earthquake, the town has used the coastline as a dump. Household items, glass, appliances, and even cars were chucked over a cliff, landing onto the beaches below and carried out to the underbelly of the sea.

The sea had no choice but to swallow the waste. But in a gesture of reparative work, the sea regurgitated this trash into words of colored jewels—as if a mariner's retelling of "Diamonds and Toads": the magical tale in which a compassionate daughter is blessed by a fairy who bestows upon her the power of having a jewel, a precious metal, or a pretty flower fall from her mouth whenever she spoke.

Along the shore of sand embellished with colored glass, Mother is collecting round hollow seaweed bulbs from bullwhip kelp, also known as ribbon kelp, edible kelp and bladder wrack. Its scientific name is *Nereocystis luetkeana*. In Greek, *Nereocystis* translates as "mermaid's bladder," which always brings a gentle smile to Mother's face. She has brought along her pocket knife to sever the round hollow bulbs from which emerge the ribbons of seaweed. She delicately places each bulb in a woven basket. She explains to Aaron and Mary that these little balloons are the reproductive part of the seaweed. They are readying

themselves to broadcast sperm and eggs into the water, in hopes of generating baby seaweed. The children half understand. Such facts generate in them future conversations about seeing seeds in their own belly buttons, which are sperm. The children will investigate their navels with a reverence, exhilarating and terrifying, for anything that might be a tiny seed.

Mother cautions Mary, Aaron, and Melody to only take natural things from the earth with great care.

"Remember that much of life—which lives in the land, air and sea—is invisible to us," Mother explains.

"Likewise," Mother emphasizes, "one should try to make new things out of old things, whenever possible."

The Children have heard this speech of Mother's before. They nod their heads again in agreement while saying "yes, yes, yes," in unison.

Invisible gold coins fall from Aaron's mouth.

Blue sapphires from Mary's.

Diamonds from Melody's.

Mary, Melody, and Aaron are enchanted by their treasures of glass stones, small seashells, and other bits of garage-and-house flotsam and jetsam. Aaron is especially enamored with his spark plug. The Children place their riches in jars provided by Mother: like the ones she gives them for collecting butterflies, only without the punctured air holes in the metal screw-on lids.

When catching butterflies, Mother insists that they must always be gentle. And they must always let their specimens fly free, after admiring their beauty with reverence.

- —western tiger swallowtail
- —anise swallowtail
- —cabbage white
- —large marble
- —spring azure
- —orange sulphur
- —mourning cloak
- —California sister

—rural skipper
—woodland skipper

Melody has scavenged an antique skeleton key along with her glass jewels. Mary stares at the key with greedy eyes: her heart flaps wildly like a bird.

Mary decides to steal the key, which she later does. She will place it on a blue velvet ribbon and will often wear it secretly—close to her heart.

Thump.

Thump.

It feels safe next to her heart.

This incident of the antique key is Mary's earliest memory of a desire to steal.

It's Saturday and Mary is playing at Aaron's house. Mary and Aaron are painting with watercolors at the kitchen table. Mary is a bit bored. Mary takes notice of the plastic robin's-egg-blue "Minute-Minder" egg timer on the kitchen counter. Its full-moon face has a big dial in the middle.

The beauty of the black numbers going around...

60 . . . 55 . . . 50 . . . 45 . . . 40 . . . 35 . . . 30 . . .
25 . . . 20 . . . 15 . . . 10 . . . 15 . . . 10 . . . 5 . . . 0

Mary longs to hear the ticking seconds that its face promises...

TICK . . . TICK . . . TICK . . . TICK . . .
TICK . . . TICK . . . TICK . . . TICK

The thrill of the bell, when it hits one minute. Like a telephone toy.

BRRING-BRRING . . . BRRING-BRRING . . .
BRRING-BRRING . . . BRRING-BRRING

Like a cat ready to pounce, Mary is ready to steal.

Mary feels "Little Bird" trapped within her girlish breast again, just like she did when she saw Melody's antique skeleton key from Glass Beach.

FALAPAPA-PAP . . . FALAPAPA-PAP . . .
FALAPAPA-PAP . . . FALAPAPA-PAP

Little Bird beats her wings irrepressibly.

Mary gets down from her chair and winds up the Minute Minder. Slowly with pleasure. The countdown begins.

60 . . . 55 . . . 50 . . . 45 . . . 40 . . . 35 . . . 30 . . .
25 . . . 20 . . . 15 . . . 10 . . . 15 . . . 10 . . . 5 . . . 0

Ticking seconds, hitting zero with the furry of an excited little bell.

FALAPAPA-PAP . . . FALAPAPA-PAP . . .
FALAPAPA-PAP . . . FALAPAPA-PAP

As Mary is leaving Aaron's house, she takes a detour to the kitchen. No one is around. The plastic robin's-egg-blue and milk-white "Minute-Minder" egg timer is still there on the kitchen counter. It beckons Mary with its adorable full-moon face, black numbers going around, big dial in the middle wanting her hand. Mary hears its sweet mute call. Mary grabs it and moves toward the front door. Moving swiftly. Quietly. No one sees Mary. No one hears Mary. Hush hush. Mary feels joy.

Mary looks under her bed and pulls out her hoard.

Aaron's small cobalt blue Swiss Army knife. Mary opens it and gently slides its knife edge along her thumb.

Mother's red lipstick: the name of the Revlon color is "Cherries in the Snow." A week ago, when Mother emptied her purse and was frantically looking everywhere for her "Cherries in Snow," Mary said nothing. Mary kept putting together her jigsaw puzzle of a hundred pieces—a large photograph of orange clownfish in the blue ocean.

Teacher's schoolyard whistle: an Acme Thunderer with a dried pea inside. When Mary blows into the whistle—air passes over the pea and produces a delicious pure tone—a fresh reverberation that takes Mary higher—like running along the shore of the Pacific as the morning fog is just burning off. Mary wonders if the whistle was a gift to Teacher? Mary runs her fingers over Teacher's initials engraved on the side: AMP. When Mary thinks of her, she remembers the day when the class thought Teacher was crying, but it was only her new contacts, which were irritating her eyes. Mary was disappointed—because she had been drawn to Teacher's tears, thinking they were real.

Mary goes over her treasures when no one is near. Mary must be sure that she will not be disturbed. Luckily Mary's secret remains unknown to her household. No one cleans under the bed. She wants to tell Melody. Maybe she will.

Mary's objects feel good in her hands — even good in her mouth.

When the wind-up "Minute-Minder" hits 0, she kisses it gently, taking its vibration on her tongue, as it lets loose its excited little bell. She thinks of the frantic little punching bag in the back of her baby cousin's throat when he was desperately crying for his mother: his uvula. Latin for "little grape."

Mary dares to slip the closed lipstick tube into her mouth, challenging herself to taste its foreboding metallic flavor, worse than copper pennies. But Mary does like the lipstick tube's bumpy texture, like a sewing thimble. Mary gently pulls open "Cherries in the Snow" and gently traces the red-hard-creamy tip with the tip of her own tongue. She never puts the lipstick on.

Mary is frightened to put the cobalt blue Swiss Army knife into her mouth, even when it is folded closed. So, she holds the tightly closed Swiss Army knife in her own tightly closed fist, until it grows warm.

She sticks the antique key up one nostril, but only partially, and slowly spins it around.

Cold inert objects present no temptation for Mary. Her treasures are all possessions belonging to those she loves and knows: Mother, Aaron, Teacher, Aaron's mother, Melody. But never Father. She would never take anything of Father's.

Stealing stops the . . .

FALAPAPA-PAP . . . FALAPAPA-PAP . . .
FALAPAPA-PAP . . . FALAPAPA-PAP

Even though Mary also loves the . . .

FALAPAPA-PAP . . . FALAPAPA-PAP . . .
FALAPAPA-PAP . . . FALAPAPA-PAP

She can only take it for a little while, like anything that feels really, really good.

Mary is nine.

Inside Mary's head. Inside Mary's body. Something turns to ice, as she stares down at her boiled egg—carefully sliced open at the top—so it can be scooped right from the shell. Drips of marigold-yellow yolk ooze down its warm brown shell and onto the blue and white Royal Copenhagen egg cup atop a matching bread plate, which offers a slice of buttered toast—cut diagonally into two "scalene" triangles. Mary knows this term: she is very good at math.

"Mary, would you like a little orange juice with your breakfast?" Mother gently pleads.

"No, thank you."

"Mary, would you like some milk to drink?"

"No thanks."

"Some apple juice?"

"No thanks. I'm fine."

Mary stares at Melody's empty plate, save for a few crumbs of buttered toast and a smear of yellow yolk on her plate. The shell in Melody's egg cup is scooped clean. Melody has already left the table to brush her teeth and choose a barrette for her hair. It is almost time for Mary and Melody to head off to school in their new Mary Jane shoes—no more saddle shoes for them.

Father, who rises early and has his breakfast before everyone—drinking a whole pot of percolated coffee before heading off to the university—is long gone.

Each day Mary politely refuses food more and more, until she barely eats at all.

Mary chooses hunger. Those less sympathetic would say that Mary indulges in the luxury of preferring not to eat.

It's dinnertime. Mary, Melody, Father, and Mother are all sitting in the dining room of their San Francisco house — with its pretty bay window, complete with a window seat for taking in a view of the bay. The walls are a very pale fawn brown — the same lovely tone of the chickens' eggs on the small Salinas farm owned by Mary's maternal aunt. Mary climbs down from her oak Mission-style dining room chair, takes four colored pencils out of the pocket of her wide-wale blue corduroy pants, and adds some more red to the drawing that she has already begun on the wall. It is a picture of a girl in profile, with long brown hair and a strange pointy hat. The girl is holding a watering can and is giving three tulips a drink: a black one, a yellow one, and a red one. Mary restricts her drawing to a small area on the dining room wall to the right of the bay window.

Mother lets Mary draw on the dining room wall because Mother is so afraid of saying "no." Mother's afraid that doing so might cause Mary to get angry and eat even less.

Mary might die.

Mary has heard Mother and Father whispering about this.

Anorexic Mary is ethereally beautiful and sparkling. Translucent. Like the shallow water along the shore of the sea. Like juvenile cowfish. Like transparent squids and octopus. You can see through Mary's skin. You can see her thin blue veins. Under her wrists. At her temples. Next to her hipbones. Even at the top of her thighs. Delicate blue veins pulsating with the beat of her heart.

lub-dub

lub-dub

lub-dub

At first Father was blind to the devastation at hand, giving Mary the affectionate nickname of Theco: short for Thecosomata, the scientific name for the sea butterfly. And so close to his name: Theo — short for Theophilus. Less than a centimeter in length, Thecosome pteropods are free-swimming sea snails that live in the open waters of the ocean, not on the seafloor. Many have shells so fine that they are transparent. No bones. They seem to be made of nothing at all.

Father did not know how bad things were back then.

Or perhaps Father chose to remain helpless, convincing himself that things were not that bad.

The less Mary ate the higher her exhilaration.

Soon, Mary's talent for refusing food took a very serious turn.

Mary's body temperature becomes low.

Mary's hair turns thin and dry.

Melody takes it upon herself to save Mary.

Melody secretly feeds Mary.

Mary takes to Melody's gentle cooing.

Mary takes for Melody.

Alone in Mary's bedroom, Melody slips premasticated food from her mouth into Mary's.

"Open your mouth and close your eyes," Melody sweetly chimes to Mary.

Mary never knows what is coming. A kiss of apple pie with cinnamon—a kiss of cornbread with honey—a kiss of Mother's samosa, which she makes with pride for Father, to remind him of his trips to Jodhpur, filled with potatoes, green peas, fennel, garam masala, ginger—a kiss of San Francisco sourdough bread with unsalted butter—a kiss of artichoke leaf dipped in mayonnaise—a kiss of bubbly Coca-Cola.

For someone who hardly eats, Mary is a girl with promiscuous tastes.

Melody mouths to Mary an extra special kiss of Mother's masala dosa, prepared with great fragrant joy—rice, lentils, potato, fenugreek, ghee, curry leaves. The next mouthful leaks into Mary's mouth with the special accompaniments of coconut chutney and sambar.

Kissing is a form of eating.

Suckling after the milk is gone.

Come and kiss me.
Never mind my bruises,

Hug me, kiss me, suck my juices.

At first, Melody's kisses were force feeding. Aggressive, down to business. Beak to beak. Like a mother bird pushing regurgitated food into the mouths of her little nestlings.

Soon, as Mary began to eat, the situation grew a tiny bit playful. Mary would tease Melody with games of mild resistance to her older sister's nutritive kisses.

Eventually the kiss-feeding became quite efficient, with Melody neatly using her tongue as a soft spoon to feed her baby sister.

And finally, resistance was all but forgotten and Mary would open her mouth and close her eyes as she dutifully waited to be fed. Mouthful upon mouthful of mouth-watering food was *kissed* into Mary by Melody, as if it were the most natural way to eat.

Melody knew that at any time the always willful Mary might overreact and shut her lips in tight refusal. So Melody strategically used all of the patience she could muster: an admirable and useful skill she learned from Mother.

Mary is in her room. She has escaped the supper table. Mother and Father let her go. She didn't even feel like drawing on the wall.

Mary knows it will be a long time before Melody comes to her room to feed her. Melody will talk to Mother and Father—telling them funny stories about the other kids at school—will finish everything on her plate—will bring in her own dishes and Mary's too.

Mary waits for Melody, the way a stubborn child can wait.

The way you learn to wait when in love.

To love is to wait.

From her room Mary can hear the radio in the kitchen playing the evening news, the peaceful clatter of Mother's careful and methodical dishwashing. As if everything is normal.

Eventually, Mary hears the familiar sound of Melody's bare feet, like cat paws, softly romping down the long hall on the Persian carpet.

Melody is tenderly singing "Pretend"—a song she learned from their Mother, who loves Nat King Cole.

Now Mary hears the slow turning of the doorknob and the release of the lock.

The door opens.

There's Melody, looking gently at Mary—her eyes like sky lupines plucked for her younger sister.

Melody quietly shuts the door behind her, soundless as a mouse.

Melody feeds Mary religiously, obsessively, at regular intervals. Holy anorexia.

Mary does not know what she loves more—the kiss feeding or the secret itself.

After their delicious ritual of sisterly feeding, Melody begins to photograph Mary with her magical Rectaflex camera: an extravagant tenth birthday gift from Father. He bought it for Melody when he was a visiting scholar in Italy presenting a series of lectures on Jodhpur painting and utopias.

With the same religious fervor that Melody calls upon for feeding Mary, Melody believes that taking photographs of Mary will keep Mary alive.

The Girls enjoy loading the film, looking through the viewfinder of the camera and hearing the click of the camera: the metallic shifting of the plates. A voluptuous sound.

When Mary sits close to Melody, she feels inseparable from her big sister.

Even when Melody is not near, Mary always feels her there. It's the same closeness that Mother feels with the life of the land, the air, and the sea. A closeness that is just too close to see.

The camera's record of this day and the ones before and the ones to follow will never be developed. Melody understands that Mary cannot bear photographs, a feeling, a conviction, which will stay with Mary for her entire life.

(As Mary would often say after the success of her most famous dance, titled *Caul*: "That's not my way. I refuse documentation. No photographs. My life is dance—and dance is of the moment. Dance

should remain pure and unmarked." And then pausing, always looking skyward, gently laughing with a wry smile, she would be sure to add: "I worry I might lose thin ghosts of myself, like layers of skin, with each picture taken, as was feared by Balzac.")

Photographs have always made Mary uneasy.

When she was a child, looking at photographs of Father, especially pictures of him from long ago, she felt, as if she was being gently fondled by death. Strangely drawn to the feeling: Mary would dare herself to look closely, while taking breaks from the pull of the image—averting her gaze. Even though Father was very much alive.

Photographs touched her, like seaweed.

Wrapping around her ankles.

Coming between her fingers.

Skimming her belly.

Cold tactility.

Mary treasured the dead feeling of seaweed, long after she stepped out of the ocean. It stuck to her skin. An afterimage of touch.

Mary felt the same compelling unease the first time she heard a recording of her own voice in kindergarten. This is a startling experience for everyone, but especially for Mary. For Mary had a funny voice. Even as a child, her voice was unusually childish. A Glockenspiel voice, which matched her small stature. Just as her stature would always remain childlike, she would never lose this voice. Her larynx would always be occupied with a wooden, red Schoenhut toy piano, like the one that the Girls played with, even when they had stopped playing with toys.

The exposed 35mm rolls of film will hibernate inside their cold, dark, metal canisters, within the darkness of Mary's top dresser drawer... until they are lost.

THE PACIFIC IS MADE OF THE BLUES OF MARY'S DREAM OF A GLASS HOUSE

When Mary finally makes it to the top of the rocky azure-mountain, covered in patches of violet and sky-blue wildflowers, she sees the tiny glass house. The house is the just-right size for Mary. She opens the glass door and steps inside—even the couch and the chairs and the little sleigh bed are made of glass—with soft, inviting cushions made of olive-green and lilac-velvet.

When Mary wakes up, she opens one eye and discovers she is lying on her stomach atop the family's "beach blanket"—Mother and Father's old white chenille bedspread, which has now been replaced by a new one. Melody, still asleep, is next to Mary. Mary indulges in the warmth of the heat from the rays of the sun. Her ears awaken and take note of the crash of the waves, the eerie *huoh-huoh-huoh* of seagulls, the distance laughter of children's play, as if from a far-off country, the bark of a happy dog. Mother and Father are sitting in their beach chairs, absorbed in reading their books. Mary sits up and gazes out to the Pacific, her right cheek patterned with pink indentation from the intricate chenille tufted details—and there is no glass house on a rocky azure mountain, covered in violet and sky-blue wildflowers. But there is the beautiful Pacific: sparkling aquamarine before Mary's eyes.

The Pacific is made of the blues of Mary's dream of a glass house.

LIKE THE JELLYFISH THAT WASH UP ON THE BEACH THAT SHE SOMETIMES ACCIDENTALLY STEPS ON

Mary is with her parents and Melody in Pacific Grove to see the overwintering monarchs. The butterflies are suspending themselves from the trees in large groups—creating monarch cascades, which appear curiously in the shape of butterfly nets. The long dancer legs of the monarchs are perfectly built for holding onto the sickle-shaped eucalyptus leaves.

"Eucalyptus trees," Father explains, "came to America from Australia and are well suited for sheltering these thousands upon thousands of monarchs, which have flown as far as two thousand miles to get here. When the butterflies arrive, they are very tired. So they rest quietly in the trees, their wings closed, camouflaging themselves as dead leaves, until the sunlight warms them up enough to fly. Monarchs are very sensitive to cold. And since eucalyptus trees bloom in winter, the butterflies have some delicious nectar to eat while they wait for spring."

"When spring comes, the increasing temperatures and daylight hours in February trigger the development of their sexual organs."

"Look, girls," Father commands while pointing all around him, "see the male and female monarchs performing their mating flights? Do you see them spiraling around like lovesick dancers?"

"After all of their cavorting, soaring, turning, twirling—the coupled pair will rest overnight. During the night the male will use the claspers on his abdomen to attach to the vaginal groove of the female. Once attached, the female cannot get away and the male transfers a nutrient-rich sperm packet to the female. The process can take up to sixteen hours."

Melody giggles and smiles at the mention of "sexual organs," "vaginal groove," and, especially, "nutrient-rich sperm packet." Father told the Girls about the birds and the bees, as soon as they could speak—always using the often-baffling, somehow embarrassing, proper terms.

Mary listens in horrified silence.

Likewise, Mary is horrified at the very sight of so many butterflies. So much muchness.

These abject feelings had already been fed by Mary's teacher when she showed her class the educational film entitled *Monarch Butterfly Story*.

While sitting in her wooden chair, secured to her wooden school desk by metal bars and large screws, painted shiny grey, so that no one could move their seat—Mary watched the 16mm Kodachrome film on a movie screen that the teacher pulled down from the top of the smooth dark-green chalkboard. The eleven-minute gloriously colored movie, with its meticulous photography and perfectly executed time-lapse camera work, shocked Mary.

A spongy caterpillar with a frightening suit of black, white, and yellow bands—like a zebra.

Two sets of black tentacles on the front and back ends of its creepy body.

The unbearable change from caterpillar to pupa.

The confident male narrator of the educational film informing the audience that the caterpillar has turned to a kind of soup inside the pupa.

For a while, Mary does not see anything happening within the skin of the milky-green, transparent pupa with the texture of gelatin.

That is, until the neither/nor creature begins to collect itself in order to form new parts.

Flashes of black and orange.

The sac of the pupa became very full with the wings of the becoming butterfly.

The pupa becomes very crowded.

No room to move.

Seemingly without warning, the folded and moist butterfly breaks through the thin casing and pushes itself out of from the pupa.

Mary feels ill.

The discarded pupal case is like the dried Elmer's glue that Mary

enjoys peeling off of the tip of her finger, only gross and wet—like the embryonic sacs of the kittens she once saw being born, or like the jellyfish that wash up on the beach that she sometimes accidentally steps on.

Mother wonders how Mary survives on so little food. And despite Melody's commitment to feeding Mary in secret, Mary remains very thin.

"Don't you want to grow, Mary?" Mother asks.

"Not really," Mary replies.

Mother, on the advice of the pediatrician, brings Mary and Melody to the afternoon dance classes for children taught by Anna Halprin. Their kind pediatrician believes in nature as therapy, and he knows that Anna teaches her classes in the outdoors on an immense redwood deck surrounded by madrone trees. When the children in Anna's dance classes are leaving, she always asks each of them: "What are you taking with you from the natural world?" Anna's words will resonate in Mary's mind for her entire lifetime.

The pediatrician believes that nature and movement, especially in a loving environment away from the home, could help Mary—especially if Melody is along.

The dance deck was built by Anna's kind and loving husband, the landscape architect Lawrence Halprin. Anna calls her classes "dance experiences." The ceiling for the dancers is the blue sky. The corps de ballet are the magical madrones that grow all around the deck—which bend, turn, lean, and twist their trunks in order to outstretch nearby trees in competition for the sun.

Melody and Mary take their first "experiences" in the spring, when the madrones blossom bell-shaped white flowers that fill the air with a lilac scent, alongside the distinctive smell of Northern California: pine and eucalyptus. As they are leaving Anna asks: "Mary and Melody, what are you taking with you from the natural world?"

Summer is marked by a dramatic costume change: the madrones drop their flowers and discard sheaths of cinnamon brown-red bark in velvety piles on the forest floor. It is a surprise to see the newly formed, smooth yellow bark exposed in their undressing, like flashes of bare skin.

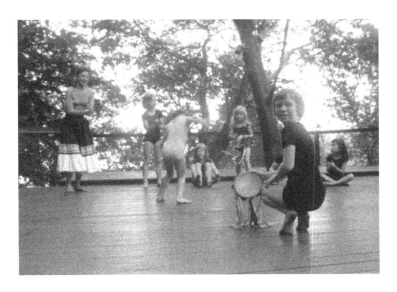

When the children in Anna's dance classes are leaving, she always asks each of them: "What are you taking with you from the natural world?"

In autumn, the madrones give way to clusters of red berries growing among their broad, oval, leathery greens.

The madrones close into winter without berries, without shedding bark, without bell-shaped flowers, and a tight refusal to let go of their leaves. But even in winter the sun still shines, and the ceiling remains blue—it is California, after all.

Bodies of children, accomplished young apprentices and well-known dancers of the time—including Simone Forti, Yvonne Rainer, Merce Cunningham, and Ruth Beckford—enjoyed limbering up on Anna's deck and taking flight in dance. Ruth was the first African American in Anna's company.

The hush of the shock of a Black woman not doing tap but modern dance was a sound that Ruth was only too familiar with.

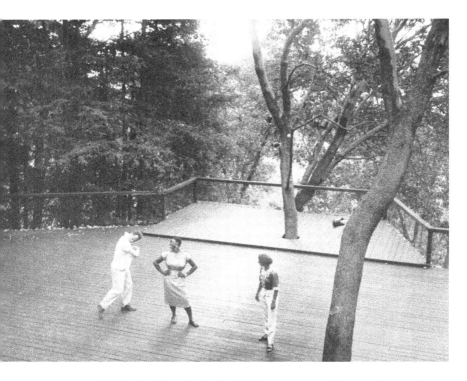

The hush of the shock of a Black woman not doing tap but modern dance was a sound that Ruth was only too familiar with.

As he dances, he whirls and punches and turns and stomps . . .
his arms with the grace of a swan.

While sitting on the redwood deck, next to Anna and Melody, Mary watches Merce dance *Changeling*. She is using her watcher eyes with great focus. Mary sees that he is a beast of many beasts. As he dances, he whirls and punches and turns and stomps—exposing his hedgehog nose—his fox slyness—his whippet energy—his brown-eyed horse muteness—his straight-up frog jumping—his leaping like a doe—his snaky ground-hugging slithering—his arms with the grace of a swan.

Fairytale modernism.

APPETITE

One day after class, Anna offered Mary a piece of orange sprinkled with sugar. And she took it. And she put it in her mouth. And she chewed it herself. And she swallowed it. And Melody watched. And Mary said: "Thank you" to the wonderful modern dancer, who was a mother of two girls herself and who liked to mother all children.

And when Mary slipped her bare feet into her blue canvas Keds to go home and began to walk out Anna's front door — even as the young child she was — she knew that she had begun her life as a dancer.

Inside Mary's belly, legs, arms, fingers, feet, toes, neck, head, lungs, heart, brain — dance manifested itself as a strong hunger to be fed.

Like a California earthquake along the San Andreas Fault, the moment was seismic.

Later, much later, at a New York party given by the dancer Trisha Brown in a loft crowded with passionate bodies and love for the energy of dance, Mary tells Merce that she understands why he wants to invent all these new kinds of movement — but why does he have to do them so fast? Merce replies with eyebrows arched high, eyes like saucers: "Appetite."

WE'VE DANCED WITH RUTH AND MERCE ON ANNA'S REDWOOD DECK

On stage for the opening dance were eight women jumping, swiveling, spinning, and kicking. They wore crisp white-cotton blouses, with scooped necklines and short puffed sleeves — neatly fitted headscarves (also in white cotton) — and bold colored wraparound skirts, printed with large orange circles and fantastical tropical lime-green vine leaves. Underneath their skirts were full white petticoats. Their feet were bare.

The women moved with an unstoppable energy riveted by the 6/8 and 4/4 rhythms of the Afro-Haitian drums being beaten by four shirtless male musicians. They wore baggy white pants rolled up to their calves. They danced in place to their own palpitating beat — erotically charged, athletic — without moving their feet, which were also bare.

On their heads, the female dancers balanced props of colorful papier-mâché tropical fruits on wooden trays, each featuring a tall joyful pineapple, comically caught by the pulse of the intoxicating drumming.

The inner cultural ears of the mostly white audience of UC Berkeley's Wheeler Auditorium were opened to sounds they had not experienced before.

When Mother and Father returned from seeing the Ruth Beckford African-Haitian Dance Company, the Girls exclaimed in unison: "Can you believe that we've danced with Ruth and Merce on Anna's redwood deck?!"

AT LAST, THEY COME OUT—EXPLOSIVELY BUT GENTLY

Mary is ten. It's Saturday. Father has taken Mary to Steinhart Aquarium in Golden Gate Park. It's a special trip, just for the two of them. They've come to see Eugenie: a 180-pound, fat, placid seaweed eater with sad eyes and a permanent smile—a magical beast who looks to be part hippo, part walrus.

Eugenie is a dugong, a submarine creature related to the manatee that was caught by an indigenous fisherman off the Palau Islands, an archipelago of green lush dots in the blues of the South Pacific.

The night before their visit to the aquarium, Father points to the Palau Islands on Mary's globe of the earth, which sits on her painted-red wooden desk, with its matching painted-red chair. The globe has a clever light inside. Every night, Mary switches it on so as to illuminate a corner of her bedroom. She finds it very comforting.

In the light of the globe, Father tells Mary that Eugenie is believed to be the only dugong in captivity anywhere in the world. Father asks Mary how she feels about this.

"I want to see her, but I don't like her being away from home and out of the ocean."

Father and daughter then move over to the bed. Side by side, with the additional light of a bedside lamp, Father reads to Mary from *Time Magazine*, with troubled eyes. Father's eyes are very expressive. They often glass over with tears of emotion: sadness and joy, or both. But Mary has never seen him actually cry.

> Eugenie's captor hauled his prize ashore, propped her up in a taxicab and trundled her through his village as a curiosity.
>
> Next day Dr. Harry & Co., who were collecting marine specimens nearby, raced to the village and bought Eugenie for $20. She was given a sulfa treatment for her spear wound and nursed back to health (on a diet of clams and cucumbers) in a local

> swimming pool. No available aircraft could carry a tankful of water big enough to enclose a sea-elephant, but since the taxi ride proved that Eugenie could live out of water, Dr. Harry decided to fly her home on an air mattress.
>
> Forty-eight hours and three planes later, Eugenie landed at San Francisco, weeping copiously.

The weeping, explained Dr. Harry, who kept Eugenie company, is the dugong's only way of keeping its eyes moist when it is out of water.

Mary and Father make sure to see Eugenie first. Eugenie seems to smile at Mary. Mary smiles back.

Father smiles too.

Mary holds Father's large hand as they continue walking, making a stop to see the giant Pacific octopus. From the placard on the wall, Father reads to Mary the creature's scientific facts, pausing over these words:

> They live to be about four years old, with both males and females dying soon after breeding. Females live long enough to tend fastidiously to their eggs, but they do not eat during this months-long brooding period, and usually die soon afterwards.

Mary meets the gaze of the orange-colored giant Pacific octopus. No smile for this monster-thing. Its hue and texture are that of a tangerine peel. Mary can only see one eye, also orange, which protrudes from the side of its head—visible between a slow ballet of long tentacles. White suction cups dot its orange dance tights. The octopus's black pupil is a horizontal slit (like a goat)—and unlike Aaron's cat (which is a vertical slit)—and unlike Mary's (which is round). Mary cannot make sense of its strange abject form. Its bulbous head is alien. Where is its mouth? Where is its body?

The octopus turns and reveals to Mary both of its magnificent eyes, across which seem to be playing an obscure and inhuman dream.

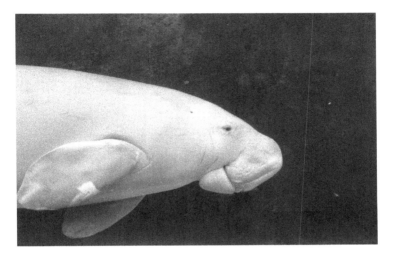

Forty-eight hours and three planes later, Eugenie landed at San Francisco, weeping copiously.

"Father," Mary asks, "how does it keep its legs from getting tangled up?"

"I don't know my dear . . . a real mystery."

Its effect on Mary is very unpleasant—she can no longer look. She turns her gaze away from its magnificent eyes.

"Are there seahorses here?"—Mary asks Father.

Standing before the glass tank, Mary is mesmerized by the daffodil-yellow and poppy-orange seahorses, swimming slowly and upright, with fixed gazes. It's a dance without emotion. Without drama. Without story. It's a game of repetition. Of empty tasks. Of meaningless patterns. The seahorses move as if choreographed by Yvonne Rainer, the austere minimalist dancer with the quirky straight-faced wit.

Father is teaching Mary about seahorses.

Father and Mary are looking at a variety known as the "slender seahorse" or "longsnout seahorse." The females are usually yellow and the males usually orange. Mary loves yellow: it's her favorite color. Males and females have brown or white spots, which dot their heads, bodies and tails. When courting, males may change color and inflate their belly pouches, as if selling the service of their male wombs. Males and females perform a ritualistic dance around each other.

Longsnout seahorses are sexually mature at three inches and are ovoviviparous.

Little fins on their backs propel them through the water—tiny motors with miniscule hummingbird energy—fluttering up to thirty-five times per second. Petite fins near the back of their strange snouted-heads take care of the steering. A toy-size dragon tail anchors the slender seahorses to sea grass and coral.

Mary is shattered to learn that seahorses are inept swimmers—who easily die of exhaustion when caught in a storm-roiled sea.

Seahorses suck in their food (plankton and little crustaceans) through their tiny horse snouts. Voracious eaters, they can eat as many as three thousand brine shrimp per day.

The father seahorse helps the mother seahorse by allowing her to

lay her unfertilized eggs in his pouch. He will fertilize the eggs for her in this clever brood pouch. When his belly is big with baby seahorses ready to be born, he also gives birth for her. He wiggles and twists this way and that. At last, they come out — explosively, but gently.

Mary is eleven years old and is sitting next to Melody on the Halprins' dance deck. The students are watching Anna's dance, called *Branch*. The year is 1957.

The blue sky is the theater's ceiling.

Magical madrones encircle the deck.

The madrones are the corps de ballet.

In order to steal limelight-sun, madrone trunks bend, lean, turn, and twist.

Madrone branches reach, hide, point, flower and leaf.

On the stage, the principal dancers—A. A. Leath, Anna Halprin, and Simone Forti—are one with the woodiness of the madrones and the redwood deck.

Anna and A. A. pose like trees. Simone inches across the deck on her belly—her right hoof kicked up to touch her magnificent real-tree-branch antlers, which hide her eyes. Her elbows are legs. Her hair is a round nest atop her head.

Now A. A. has the antler-branches, as he inches up to Anna and Simone. The two women lie twisted on their backs. Their fleshy branches are stretched open. Like felled trees in waiting.

Branch is perennial.

Branch is *philosophy* (love of wisdom) through *dendrophilia* (love of trees).

For Anna, the concern is form in nature—like the structure of a tree—not in its outer appearance, but in its internal growth process. For a seed to bear life, it must first fall to the ground and die. It is through the process of dying that the seed bears life and is transformed into a seedling tree.

> Mary watches A. A., Anna and Simone become Daphnes.
> Become laurel trees.
> Mary watches A. A., Anna, and Simone become Actaeons.

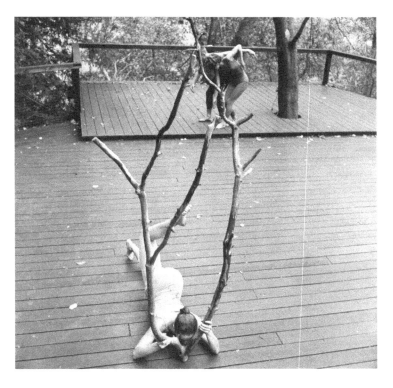

Simone inches across the deck on her belly—her right hoof kicked up to touch her magnificent real-tree-branch antlers . . .

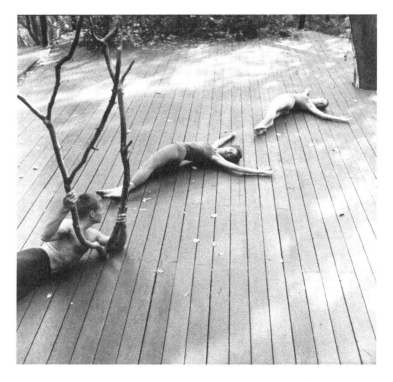

The two women lie twisted on their backs. Their fleshy branches are stretched open. Like felled trees in waiting.

Become stag-trees.
Mary thinks she hears familiar faint branch-cracking sounds.
Metamorphosis.
Bernini through the eyes of Anna.
Modern-Baroque.
Arm branches.
Toe roots.
Finger leaves.
Waist-belly-bark.
 Heart beating under bark.

Mary is seventeen years old. Mary is in Aaron's kitchen. Last night Mary and Aaron graduated from high school. Mary and Aaron are gossiping, eating popcorn. They are tired. They are nervously bored. Life is on hold. But only for a little while.

The drama of life is ready to spring and pounce.

"Aaron, let's go for a walk. Let's go to 'the woods,' like when we were children," suggests Mary, her eyes looking sad, even though she is smiling.

The two head out to the nearby elementary school, where everything began.

When they were children, school seemed so far away. An interminable walk home.

Another country.

It is evening, full of the late light of summer.

They reach "the woods."

In a field beyond them is a quail—small, plump, gray—with a short black plume curving forward from his crown. His face is black and white; he is sitting alone in a field of strawberries. The fruit is bright red, succulent. If the quail were to be startled, he might flush from the field. But given a choice, he prefers to escape on foot.

The woods still smell of . . .

—bitter-orange peel
—rotty-weedy-green forest
—pear-clean
—soapy-spicy-powdery-mossy-needle arboreal
—juniper

—rose-medicinal
—amber-herbal
—and of Aaron
—fresh and sweaty
—like young garlic
—like a tender smooth white bulb giving way to new-green
—his freckles like burnt toast

Aaron will never smell like a man. Like dried garlic simmering with other smells hard to pin down. His freckles will forever smell of burnt toast.

"There's a caterpillar on your neck," Aaron whispers to Mary.

Aaron touches it gently.

Aaron breathes heavily on Mary's neck.

Aaron, yearning to unlock the holding-waiting feeling that engulfs them, kisses Mary deeply, out of the blue. Was Mary expecting this? Mary does not like the feeling of Aaron's aggressive tongue.

Aaron slowly pulls back. His tongue no longer in Mary's mouth. His body no longer pressing against her.

Defeated.

A long pause.

They look deeply into each other's eyes, without flinching. Seemingly without reason.

Mary breaks the spell by looking down.

From her skirt pocket, Mary pulls out a piece of red sea glass: frosted and soft in texture, from years of weathering, tumbling, aging in saltwater and sand. "This is from our childhood days," Mary says, with a little self-conscious laugh. "Here keep it to remember me. It is made of glass. But I'm not." Mary says these words very carefully—pretending that she could love Aaron. As if she might have liked the kiss.

But Aaron and Mary both know the truth.

Mary does not love Aaron.

I COULD SEE THAT THEY WERE RUNNING AND SKIPPING AND TO ME IT WAS DANCING

Mary is seated in a springy, red-velvet, front-row seat between Mother and Father at UC Berkeley's Wheeler Auditorium. Right before Mary's eyes is Merce—he is performing *Field Dances*. Mary is so close that she can see his eyebrows, full of animal-animism, his high forehead crowned in tight archaic curls ready to unspring. Mary thinks she sees satyr horn buds. His eyebrows are little bird wings for his face, ready to take flight.

Robert Rauschenberg designed the colorful costumes. The female dancers wear leotards painted like watercolors on wet paper—dripping and spilling cantaloupe-orange, lemon-yellow, moss-green, sky-blue—like the early paintings of Eliza Vesper, a painter Mary did not yet know. The men wear short sweatshirts, with clean wide stripes of sky-blue and ivory, over tights painted in watery polka dots also of cantaloupe-orange, lemon-yellow, moss-green, sky-blue. The women are inconvenienced by huge ivory-colored chiffon panels, transparent and diaphanous, wittily attached to their backs. Like Fra Angelico angels, only their wings suggest mosquito nets or parachutes.

> The music by John Cage was "as free to act as it chooses," like the dance itself.
> Like love.
> Like love letters from John to Merce, with a choreography of their own.
> Please kiss whatever part of you that you can reach.
> or
> Your last letter is so beautiful I cannot answer it, only read it and lie on it.

Watching Merce again made Mary's brain feel spotless, clean as a whistle. No storytelling. No mimed emotion. Like being five in the woods with Aaron.

Merce was inspired to make *Field Dances* while watching children running and skipping on the street below his window. As Merce remembers: "They were having such a beautiful time. *Field Dances* came from that because I could see that they were running and skipping and to me it was dancing."

HER VOICE IS VOLUPTUOUS, ALMOST MASCULINE

It's summer. It's hot. Mary is in New York for a month, taking dance classes at the Martha Graham School on the seventh floor of a dingy, down-at-heel loft building in the East Thirties, with a high ceiling, and worn linoleum on the floor. The windows, which overlook Third Avenue, are haunted by a thick, clingy gray dust, like the powder on a moth's wings. But the ceiling is fresh and gorgeous with garlands of pretty plaster roses, like frosting on a wedding cake. If you look carefully, you are dazzled by a single red rose in a far corner, among the horde of whites. Like discovering Sweet Briar Rose in a bevy of thickets: she, the red rose is there, just out of reach. The ornamental plasterer (like a pâtissier of days gone by), who repaired and repainted the ceiling decades ago, found he could not bear all the roses being white, so he chose one to be crimson-red, like a playing-card gardener in *Alice in Wonderland*.

Once you see the red rose, you can only see *her* and not the others.

Mary has been watching Eliza for days. Eliza is much older than Mary. She is thirty-two. Mary has no idea that Eliza is already attracting serious attention for her painting, which will only grow. As Hilton Als will write, many decades later, in regard to Eliza's painting:

> For me, Eliza Vesper's most exquisite work in her current retrospective at The Guggenheim is her large oil painting on unprimed bright-white linen: *Syllableless Sea* (1952). Unlike her earlier stained canvases that run shallow and deep with breadths of colors—fern green, orange coral, cerulean blue, limestone gray, palomino cream, peony pink, chestnut red—*Syllableless Sea* floods, streams, seeps and spills a limited palette of black-and-blue oceanic colors. Parts of the bright-white linen have been splattered with clear wax—unstained they resist pigment and shimmer white light—like stars in the night sky—or cell patterns under a microscope—or schools of fish that live deep

in the sea, in total darkness, and call to possible mates (like fireflies in a swamp) by lighting up in order to lure. Black and blue, this painting abstractly but profoundly traces the dark depths of darkness. Vesper's paint is an echo of the unspeakable: the slaves who made indigo, the slave ships that crossed the ocean, the individuals whose identities were stolen (men, women and children), so as to cast them out to sea as singular—as monosyllable black. As slave. That is what is hiding underneath the saturated depths, so full of darkness that you are compelled to look harder to see if you are missing something. Some may say that this is a modern painting, empty of meaning, but to say nothing is impossible. *Syllableless Sea* talks b(l)ack, to echo bell hooks. A voice without syllables.

Cry.

Howl.

Wail.

The silence is too loud to hear.

How do I know? I feel it, without a syllable-by-syllable explanation.

But you may feel something else unspeakable, surely beauty, at the bottom of *Syllableless Sea*?

—Hilton Als, *New Yorker*, March 2017

Eliza is often seen at the Martha Graham School.

For Eliza, dancing is a way into her painting.

Eliza is tall. She walks on her toes. Her heels hardly touch the ground. She must get this from her father, Banjoko, who is Nigerian-born. When he was young, his heels, also, hardly touched the ground. But while Banjoko walked on invisible springs, ready to leap, Eliza floats, slowly and gracefully. She saunters her father's gait. Eliza's large dark-blue, almost black, eyes stare without focus. She moves as if clairaudient—always listening—always touching the seen and the unseen—her lovely long-fingered hands before her, swimming idly, as if her world had no gravity. Around the edges of her scrubbed-clean hands, softened with lavender cream, her fingernails hold traces of

her Winsor & Newton oils: Cerulean Blue, Prussian Green, Titanium White, Cobalt Violet, Ivory Black, Cadmium Red, Bismuth Yellow, Cobalt Green, French Ultramarine. Tiny dots of perennial color.

She makes no secret of Jackson Pollock's influence on her painting—for she, too, spreads her unstretched linen on the floor, just as America's most famous postwar painter unrolled his rough canvas on the ground in the barn he used for a studio, even outside in the open.

Eliza always paints inside in a formal, clean, white studio.

And there are further differences.

Pollock performs around his canvas, as an arena in which to act, crossing one manly Sears work boot over another. Furthermore, his dance stays on the edges of his all-over splattered canvas. Pollock performs like a primal thunderstorm—raining, shaking, splattering and dripping globs of paint on the canvas.

In contrast, Eliza gets inside her unprimed canvas, using her oil paints like watercolors, thinning them down with turpentine and linseed oil, allowing the pigment to spread, encouraging halos of transparent, if menacing, colors. At times splattering dots of clear wax to resist the color so as to make tiny white lights, as she perfected in *Syllableless Sea*.

Eliza paints barefoot. Slowly painting her way out from the middle of the canvas to its edges—her heels hardly touch the ground. Her dance is aquatic. As if, moving attentively against the weight of water.

Mary sees the stars in Eliza's dark-blue, almost black, eyes.

Mary sees the midnight-fern fiddleheads, purple cyclamen, and wild violets in Eliza's dark curly hair.

Mary sees that Eliza's breast buds are broken.

In her scruffy ballet-pink ballet shoes, Mary begins to fall for Eliza. Like a falling lamb.

And with stars in her eyes and the wind in her hair—Eliza takes hold of Mary's hand—long before Mary begins to fall—long before Mary even lays eyes on her—like the delayed rays of a star.

For the first time in her life, Mary feels an extraordinary pride:

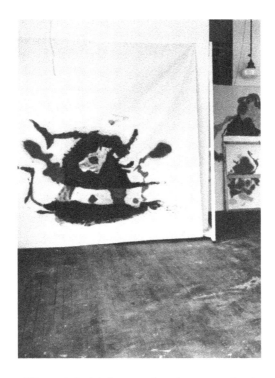

Eliza gets inside her unprimed canvas, using her oil paints like watercolors . . . encouraging halos of transparent, if menacing, colors.

Mary feels the wind and the cyclamen and the violets.
 Mary has never been with a woman before.
 When Eliza speaks, her voice is voluptuous, almost masculine.

EVEN THOUGH SHE IS A VEGETARIAN

In late July, Mary leaves steamy New York and is welcomed by the coolness of Northern California. When she returns from the Martha Graham School, Mother and Father give Mary and Melody their own antique skeleton key to the family's small bungalow in Point Lobos.

Melody is busy getting ready to begin her second year at the San Francisco Art Institute and is already living in a shared house not far from Chestnut Street. Her housemates include Ray, who is soon to become her boyfriend.

Mary moves into the bungalow right away.

When the Girls were young, the bungalow was the very heart of weekends and summer holidays. When the Girls got out of the car, they would sniff, smile and say in unison: "That's the sea."

Combing the beach near the bungalow, Mary collected treasures, especially the black and blue mussel shells, with their clumps of hair-like fibers — their halves connected at one side like toy caseinates.

Sometimes the mussel shells would be found wide open, their wings pinned open in the sand.

Most were found quietly ajar — so as to provide a peek inside the now empty home — an opalescent *rainbowy angel's fingernail interior.*

Occasionally, the animal would still be home — but Mary always left these mussels alone in their shells.

It was here in the bungalow that fourteen-year-old Mary, with the help of Mother, nursed a live orange starfish in a large jar of seawater and watched it grow back a lost arm. As soon as it became a five-pointed star again, Mother and Mary returned it to the sea.

And tucked into those days when Melody had been released from naps, but not Mary, are vivid bungalow memories. Prelinguistic memories. Colorful. Sensate.

While not quite asleep in her spindly creaky crib — the shimmering sea — if the light was right — would shine through the cream-col-

ored window shade—and the radiance would play, rest, and tremble on the Prussian blue walls of the bedroom.

A bed is a boat.

One, day, after waking up from her nap, Mother took Mary—who was not yet walking—down to the beach and set her down at the edge of the Pacific to see what she would do. As Mother expected, Mary crawled straight for the sea, determined to get through the wall of blue. There and ready, Mother wasted no time in catching the heels of her youngest daughter, so she could grab Mary by her chubby-baby waist.

Once her baby was in her arms, Mother smothered Mary with kisses while exclaiming under a veil of loving laughter: "Although you have sea-salt in your blood, you no longer have your infant gills."

Mary remembers, or at least believes that she remembers (could she?), the feel of the sea, the wet sand on her knees, the sound of the waves, Mother's jubilant laughter.

The bungalow is an existential dream of Mary's childhood—an image of enclosure that excites Mary's imagination.

Mary still imagines the bungalow as a mussel shell writ large: with its outer shell of rough bearded cedar, stained dark blue, its smooth trim painted glossy black, its interior of rainbowy angel's fingernail mostly hidden.

The bungalow accomodates the dynamically amorphic Mary Glass.

A marvelous shell that is also a magic fishing net, always refilling with new "fish" of all kinds—feeding Mary for a lifetime. Even though she is a vegetarian.

On Mary's eighteenth birthday, a second seismic occurrence, years after she took the slice of orange sprinkled with sugar from Anna—she shares the experience with Eliza in a letter.

August 18, 1964

Dear Eliza,

Breathless. Eliza I am reborn. On my 18th birthday. For two long weeks, I was feeling stuck with my dancing. Until today, I had stopped loving it. As Merce told me: "You must love the daily work."

A sea wave has found me, has opened itself to me, has danced me.

This morning, after coffee and toast with honey from Mr. Larkin's bees, I walked down to the shore. The sun had not yet risen. I made my way under the blushing light of the full August Moon. As I zigzagged along the familiar shore, I saw a cave formed of rocks that I had often seen before. But I had never seen it so exposed, so emptied of ocean. Deeply curious, I made my way up to the rocky entrance of the sea cave and stood high on one of its stony pillars. I peered inside. The Moon had drawn the tide to a threshold so low that it revealed an Under-Water Land more magnificent than any tide pool I had ever seen. The interior glowed a phosphorescent green-chartreuse: pilfered and reflected from the sea grass, flooded by shallow water, which carpeted the ocean floor.

I saw a school of small silvery fish. Like camera flashes. They had entered the green hall through the same holes that brought in the light.

Starfish clung to the walls in tangerine orange and purple bougainvillea.

Time is still. I have time to think: *Why do starfish always look a little bit drunk? Drunk when they shouldn't be . . . splayed on a wall.*

The brown urchins, like subaquatic porcupines, are clustered—in consultation—many have victims.

Strawberry sea anemone, with the coolness of watermelon, are gathered in a rock garden, made more vivid by the water, as if under a magnifying glass. *"Cushioned, pulsing, enquiring tendrils of water."*

And then . . . suddenly, without warning, I was violently thrashed into the sea by a huge ocean wave—plummeting me into violent water.

No time to catch my breath. Tumbling over and over. No ground. No sky. All water.

My blue-jeans heavy with water, like wet cement. A roaring sound enters me. A hurricane. A train. Sand scratches me—seeking every crevice of my body. My clothes heavy with water. I cannot move on my own accord. I am ocean. Time is slow. Not there.

Like a nautilus, I become all eyes. My pupils are open holes. Tunnels. Wells. I have no lenses. There are no barriers to the free flow of sea water into my eye chambers. I exchange fluids with the sea. My pupil distorts. Elliptical. Crescent. Unnamed shapes. I am breathing underwater.

I see you: with your long-fingered hands, your full breasts with their rosy areolae, your belly with its soft path of thin hair to your vulva, your legs like limbs of thoughts. You are not in me, but of me.

And then, just as sudden as the unexpected plummet, the ocean releases me. *The water has its second thoughts.* I burst out. My heart ready to beat out of my rib cage. My excited pupils enlarged.

M. xxx

THE SECRET THAT WAS MELODY'S ALONE

Caul's first performance happened five days after her near drowning, when Mary was all alone. She danced as one with the sea—beginning and ending with her back to the shore. Her eyes on the Pacific. Up to her knees in salty water, which broke into white foam all around her.

In her ten-minute dance solo *If You Couldn't See Me* (1994), Trisha Brown keeps her back to the audience while *sustaining her free-spirited, torso-twisting, arm-swirling gambits. She does this so skillfully that not seeing Trisha's face becomes only an incidental matter. If You Couldn't See Me* is an echo of *Caul* that would happen thirty years later.

The sea as dancer, stage set, floor, audience, music.
Mary as the sea.
Caul was one with the sea, as *Branch* was one with the trees on Anna's redwood deck.
Mary would practice *Caul* alone on the beach for the rest of the summer of her eighteenth year.

One early morning of late August in 1964, rosy with the same promise as the day when Mary first discovered the cave, Melody stumbled upon Mary practicing *Caul* on the beach—her back to the shore—her eyes on the Pacific—up to her knees in salty water breaking into white foam all around her.

Before beginning the drive from San Francisco to Point Lobos, Melody had made plans to set out early so she could stop along the coast with her Super 8 movie camera, with the intention of filming she did not know what. She was trying to imagine stillness as movement—as a way to approach her painting. Earlier in the year, Melody had watched the famed short movie by the French filmmaker Chris Marker, *La Jetée* (1962), which had been screened at the San Francisco

Art Institute. A montage of black and white still photographs (save for a tiny burst of moving cinematography, when the woman of the film opens her closed eyes, like the aperture of a camera), *La Jetée* is experienced as neither movement nor stillness.

Shortly before seeing *La Jetée*, Melody had finished her most ambitious painting, although she had not painted that many yet. She was still very young as a second-year painting student at the San Francisco Art Institute: with its inspiring Diego Rivera murals and its disarming view of Alcatraz Island. Surrounded by strong, ice-cold currents, Alcatraz had once been home to some of America's most ill-famed prisoners. Escape from Alcatraz was all but impossible. It had closed only a few years before Melody began her studies at the San Francisco Art Institute.

Melody's ambitious painting, her first "success," was a portrait of Mother lying naked on her bed, only partially covered with the new chenille bedspread. At Mother's feet is a basket of dried seaweed bulbs and an open book: the words on its white pages are unreadable. In the foreground closer to Mother's head, on the bedside table, is a pile of books, their spines and titles turned toward Mother's open eyes. She looks at them sleepily. When Ray (who would become Melody's husband) saw the large horizontal painting, he said how still it was, especially the books. Yet it held impending movement. It was a seascape.

Melody's discovery of Mary dancing *Caul* was serendipitous.
 Mary never saw Melody. Never knew she was there.
 This secret was Melody's alone.

Caul, 1964, will become Mary Glass's little-known signature dance, slithered out from the secluded cave that she found when the tide was low, unusually low, like a Merce Cunningham piece.

"Keep your body low," Merce would call.

Mary would dance *Caul*—a fetation of sorts—throughout the years in San Francisco, Berkeley, and Los Angeles. On small stages. On uninhabited beaches. Even on Anna Halprin's deck. Audience members quickly became Mary Glass devotees—that is, if they were not so already.

A small, humble following.

For experiencing dance as of the moment.

And then it was gone.

But where did it go?

In you.

Eliza arrives at Mary's modest Point Lobos blue-and-black-mussel-shell house.

On Eliza's left pinkie Mary spots a platinum ring with an amethyst stone. It flashes Mary like a tiny fish eye of desire. Mary averts her gaze.

Mary pretends not to notice the ring, a present, she is certain, from a lover. Probably that young printmaker that she always talks about—who often wears an overbloomed live rose behind her left ear and holds solo exhibitions in her bohemian loft in Soho. In those days Soho was very empty.

Mary had begged Eliza to come. Like only a child can beg.

Eliza sees the Pacific for the first time.

Not New York's Atlantic.

Not Nigeria's Gulf of Guinea.

They sleep well.

Mary and Eliza breakfast on coffee and toast with honey from Mr. Larkin's bees.

LIKE THE NOSES OF RABBITS

Mary is driving her white Karmann Ghia, with Eliza at her side. They enter Big Sur via the graceful Bixby Bridge, which floats sky-high, 260 feet above the Pacific. Like birds, they soar. Like dancers in an impossibly suspended grand jeté leap. The view of the sea is breath-taking. As they cross Bixby Bridge over the canyon that sheltered Jack Kerouac's cabin where he hid to write *Big Sur*, the Pacific Ocean takes up residence in Eliza's vision—soaks her imagination—turns into her renowned painting, *The Other Ocean*, 1965.

When the Pacific entered Eliza, Mary entered Eliza.

When Mary had sex with Eliza, her pink nipples twitched up like the noses of rabbits.

Eliza and Mary make love outside.

On the beach.

As two women.

Eliza moves in with Mary.

Eliza soon finds a studio space in an old canning factory near Mary's blue-black bungalow. The San Francisco Art Institute offers Eliza a cushy position teaching drawing (her first love), once a week. The job comes with a Victorian Gingerbread rowhouse on Capp Street. Eliza will stay there one night a week when she is teaching. She often has a coffee with Melody.

Eliza and Mary enjoy the Victorian gingerbread rowhouse on Capp Street, whenever they have an urge to be in the city. And to be near Melody. Life feels perfect. The stars are aligned.

As soon as Aaron fell to the earth, that terrible devouring mother that waits for all of us, he was finished. Yet he wasn't. Aaron was still battling death's final blow for one remaining minute.

A North Vietnamese soldier—small, slight, only nineteen—had become frightened when Aaron had passed him just moments ago on the trail. Aaron with the freckles that still smell of burnt toast—but his hair had grown dark, a russet acorn grown-up brown, no longer the golden-sienna of his childhood.

The communist soldier was almost hidden by lushness: giant ferns, mango leaves, fruit trees. The jackfruit trees were laden with bulbous fruit—enormous—nearly as heavy as the slight warrior himself. Light-green in color with toadlike texture, the fruit was overripe, causing a distinctive odor. Sweet and pungent, on the edge of lovely and nauseating. The communist soldier—so scared. A shocking taste rose from his stomach coming into his mouth, fruity and sour. Like the orange-flavored Tang powdered drink mix, without the water. He had tasted it before, this powder to make a drink that was advertised in America as the refreshment of astronauts.

In fear, the communist soldier—dark-skinned, five feet two inches, wide-eyed, the apple of his mother's eye—felt urine running down his leg while the taste of powdered Tang rose up his throat.

The young North Vietnamese soldier had already thrown the grenade before he had a chance to tell himself to throw it. Because the vegetation was so thick, he had to lob it high, not aiming. To this day he remembers the grenade seeming to freeze above him for an instant, as if a camera had clicked. And then, like the old-fashioned camera flashes of the past, there was a puff of white—and he saw Aaron jerk upward as if he was only a harmless marionette puppet, pulled by strings by unseen hands.

The grenade was meant to make Aaron go away—disappear. Evap-

orate. Like a child who covers his eyes and believes that the world before him has magically disappeared.

Aaron laid at the center of the trail. One eye a huge star-shaped hole—the other watered by tears of unrepeatable sorrow at dying without Mary. He looked at her—and he thought that he saw her—for the last and final time with an eye more luminous, more grief-stricken, more grateful than she had ever witnessed in their slim years of knowing each other. And Aaron whispered something to her that he believed she could hear.

A memorable death seen by no one, save for the young North Vietnamese soldier—too far away to see much, frozen in the jungle, wet with urine, both eyes washed in tears.

GIRLFRIENDS WHO TRAVELED TO THE OTHER SIDE

Approaching sunset, Mary and Eliza are cozy in the Palisades Bar at Sugar Bowl. The "Palisades" are a jagged row of steep cliffs framed by the bar's large picture window. As the day's light diminishes, mammoth shark fins of black rock thrust out of the snow—knife-cold—glittered and shadowed in blue.

"My drink tastes like starlight," says Eliza.

They are drinking Cable Car cocktails, after a day of hitting the slopes. After they finish their last sweet sips of spiced rum, orange curacao, simple syrup, lemon juice—and after their final lick of white sugar and cinnamon on the rim—and after they finish sucking the juices from the orange spiral garnish, the bartender tells them: "Ladies, the glasses are yours to keep."

Soon a full set of souvenir glasses with a charming image of San Francisco cable cars printed in gold will be carefully placed in their Point Lobos kitchen cupboard.

They are celebrating Eliza's first foray into skiing. Eliza has had a full-day, adult-beginner group-lesson with "Heinz." "Heinz, like the ketchup," he repeated—reassuring the adults, most of whom were born before the war, that this handsome, tanned German man, with a thick accent, was as American as could be. Eliza is feeling happy—she was a better skier than the other grownup beginners, which she attributes to her dance classes in New York.

"Good evening ladies," says Coda walking right up to their table in the bar and sitting down without an invitation.

Mary is meeting Coda for the first time.

Mary finds herself crazily attracted to his strong forearms. His damaged spatulate fingernails, immaculately clean, fascinate her. His weather-worn look seems to invite her in. Even while he is sitting, Mary can see that Coda is solid muscle: a contrast to his very full

feminine lips, and heavily freckled skin. (The freckles suddenly trigger an involuntary memory of Aaron. Mary quickly suppresses it. Closes down the sensation of Aaron's breath on her neck.)

Coda has the greenest eyes and a crown of sandy auburn hair with gray at the temples. Below his emerald irises, you can see the whites of his eyes, like John F. Kennedy: what the Japanese call *sanpaku*. His thick, dark auburn eyebrows are punctuated by unruly, gray hairs. Long smile lines run from his eyes down to his cheeks. His piercing good looks are holding Mary hostage along with his equally fascinating knowledge of life: the historic, the natural, the contemporary, the strange.

"*De'ek wadapush* (Standing Gray Rock) is a powerful, very sacred site for the Washoe Indian Tribe, the indigenous people of Lake Tahoe. Twice, dynamite was used to blast twin tunnels through the sacred rock to carry tourists to and from the Nevada shore, the gambling side of the lake. Tribal leaders were not consulted. The Washoe likened the blasting to entering a very sacred, historic church and bombing it. The Washoe attributed the flooding that took place in Carson Valley after both blasts as punishment from the masterful Water Babies, inhabitants of *De'ek wadapush* . . . " Mary suddenly and eerily remembers how much she loved driving through that dark tunnel as a child.

"By the time our wildflowers become scarce, the common species of Anna's hummingbirds retreats down the mountains to set up breeding territories in lower elevations. Their color is anything but common, especially the males whose head and throat flash bright rose-cochineal . . ."

"Did you ever hear about the woman in the California desert who was badly bruised but survived the meteorite that blasted through her roof on January 3, 1957 . . . ?"

For a few moments, Mary stops listening to Coda.

She turns inward to mull over "Anna's hummingbirds." Her mind flashes to an image, a strange involuntary memory of a hummingbird held between an index finger and a thumb. Its beak appears as a pulled nail thrusting out from its head—like a very long rose thorn—out-

sized in relation to the smallness of the bird's body. Held by a hand with dirty fingernails. Where is this memory from? Was it a dream?

Mary drifts back into Coda's comforting voice. He seems to be emulating the magnetism of movie stars who make use of an affected mid-Atlantic diction, like Gregory Peck's voice in *The Yearling* or *To Kill a Mockingbird*. When Coda enunciates the T of water—and drops the R of clear—Mary feels a charge, erotic and paternal at once.

When Coda starts explaining the process for making cyanotypes, a primitive form of early photography, where objects appear like white shadows on a ground of Lake Tahoe blue, Eliza suddenly lights up and momentarily finds Coda of some interest. She grabs a pen and her well-worn, crimson leatherbound notebook from her large straw bag to scribble down some notes. Eliza doesn't bother to explain to Coda that her mind is dancing, as it often is, with patterns of Nigerian indigo textiles—in which tying small stones or seeds or other objects into the fabric before dipping it into a vat of blue, blue-black or black dye creates a resist pattern of white shadows: like a photographic negative.

Coda explains, he loves to explain.

"As children, many of us had the satisfaction of making simple cyanotypes (camera-less photographs). We took sheets of rich blue, light sensitive paper out into the bright sun and placed objects directly on the paper: perhaps a hat or a sock or a flower or a wreath of leaves or a skeleton key, even a bee. Then we waited for the blue paper to turn almost white in the sunlight: about five to seven minutes depending on the brightness of the day. Next, in the kitchen sink, or the bathtub, we *developed* the image under water. While watching the blue fade and then reappear like the sped-up film of a changing sky, we saw the exquisite 'white negative' of the chosen object—the hat or the sock or the flower or the wreath or the skeleton key, or even a bee—magically appear..."

"Do you know Robert Rauschenberg, the American painter and collage artist?"

Both women nod their heads with polite enthusiasm.

"Well, it's very exciting. Rauschenberg has made huge life-size

Held by a hand with dirty fingernails.
Where is this memory from? Was it a dream?

cyanotypes of his wife Susan—well, ex-wife, he's with Jasper Johns now—nude, dressed, with flowers and ferns, even with Poseidon's spear. They are stunning, like the blues of Lake Tahoe. But terrifying, like those ghosts of bodies and flowers and ladders, which were left behind as traces of life on fences and cement steps and wooden walkways . . . after the bombing of Hiroshima."

Years later Mary will watch the film *Hiroshima mon amour*, by Alain Resnais and Marguerite Duras. She will suddenly remember Coda's wrists when she sees the young French woman ["Elle"] gaze at the twitching wrist of her Japanese lover ["Lui"]—who is asleep in their disheveled hotel bed in Hiroshima. A memory within a memory within a memory.

Coda suddenly stands up and asks Mary and Eliza to join him for a nightcap later that night. Back at the Palisades.

"Shall we say 10:00 pm?"

Mary and Eliza both smile. Mary quietly replies, trying to keep her desire in check: "Sounds lovely."

Nevertheless, Mary can see in Eliza's eyes that she is aware of the situation.

Eliza has had other girlfriends who have traveled to the other side.

MARY CANNOT IMAGINE THAT IT IS ANYTHING SERIOUS

"I'm just not in the mood, Mary. . . . You go ahead and have your Cable Car with Coda."

Eliza is curled up in a ball in an overstuffed fern-green velvet chair—her dark curly hair, like midnight-fern fiddleheads, cyclamen, and wild violets. Great thick black oblique brows, joined in the middle, tuck themselves away under her hair. Her lips are bee-stung. Her neck serpentine. Her right leg is tucked up underneath her bottom, her left leg is stretched out. Her feet are beautifully bare. She has beautiful feet. That's why Mary has given her the ring that she is wearing on the pointer toe of her left foot: a tiny silver ring with a bright green turquoise stone. Eliza, tall and lean—wrapped in a black silk kimono, with bell sleeves lined in cherry-blossom pink—gazes up at Mary with her stunning dark-blue, almost black, eyes—strange, sad, deep. Eliza slowly blinks: for a moment her large , smooth eyelids hide her dark blue, almost-black, sapphires. On the small table beside her chair: an amaryllis bursts flowers of Tiepolo pink. Eliza is reading Daphne du Maurier's *Rebecca* for the second time. Mary never tires of looking at Eliza.

"He's gay, you know, Mary," Eliza quips with her sweet, kind laugh.

As Mary is walking out the door, she adds with a knowing smile: "He's gay like Robert Rauschenberg. . . . Don't end up as Coda's wife."

"He's interesting. I just want to talk to him."

She rolls her eyes. And then slowly shuts her cold eyelids so as to hide her jewels.

Coda dunks Mary's toes in champagne and sucks each toe separately, one foot at a time.

Mary's heart races with pleasure—her body moistens, weakens—

she fails to feel the triviality of an older man dipping a young woman's toes in champagne. Or she does feel it, but she does not care?

Mary the dancer, Coda the photographer, each of them find feet as beautiful and as expressive as hands.

Coda is photographing Mary's feet with the aperture of his mouth.

Before sunrise, Mary walks in her stocking feet back to the hotel room she shares with Eliza. She quietly turns the key to the door and walks in and sees the note from the front desk that has been slipped under the door.

In neat cursive on the hotel's thick white stationary, she reads: "At midnight, Miss Glass's mother telephoned the front desk. She would like Miss Glass to call her. It can wait until morning." It is morning now. Too early though. Mary will wait until she has had her coffee with Eliza. Mother always stays up late. Mary cannot imagine that it is anything serious.

Mary will never know that Aaron had carried that piece of red sea glass, the whole time he was in Vietnam.

Mary will never know how Aaron carried/humped that memory-stone.

For soldiers, to "hump" means to carry.

Aaron humped his small stone of California sea glass throughout the jungles of Vietnam.

In Nam, Aaron would often keep it in his mouth. Aaron would imagine that the stone was Mary's tongue made of polished glass. Warm under his own tongue. Smooth to the touch, like being inside of Mary's mouth, not far from her compelling throat. Mary's stone tongue made Aaron's mouth salivate. He could taste the sea salt.

It is Mary's tongue.

The tongue of a doll with eyes that open and shut.

Aaron also humped carefully chosen practical essentials for survival. *A five-pound steel helmet. Inside the helmet were two large compression bandages, because you can die so quickly. An M16 gas-operated assault rifle — 7.5 pounds unloaded, 8.2 pounds fully loaded. A green plastic poncho, which he used as a raincoat, but also made into other things — a roof between trees, a dry floor, a carrier.*

Aaron was not the only soldier in his unit to hump a souvenir, a lucky token, a fetish — personal and intimate — but no less indispensable, than a five-pound steel helmet, two large compression bandages, an M16 gas-operated assault rifle, a green plastic poncho.

Mark humped his girlfriend's pantyhose around his neck.

Lindsay's one pierced ear humped his mother's gold crucifix, dangled from a small gold hoop.

All the men humped their imagination, which was the heaviest thing of all. Their imagination was one of the wildest places on earth. Violent, scared, erotic, crazed, paranoid, life-saving, life-destroying.

Imagination is desire. Imagination is survival. Imagination is one's downfall.

Imagination is a killer.

THE NATURE OF GRIEF

Mary calls Mother after coffee with Eliza.

"Mary, Aaron died in Vietnam last week. His family is waiting for his body to be flown home."

Mary is too shocked to cry. She cannot even bear to tell Eliza. As if she could undo it, by never saying it out loud. That is the nature of grief.

THE SAME THING

Mary more or less just stays on in Lake Tahoe. She lives with Coda in his 1920s Swiss chalet–style house on the edge of the lake. Eliza left Sugar Bowl after their three-night reservation was up. Eliza begins to use the living room and both of the bedrooms of the Point Lobos bungalow as studio space.

These days, Eliza spends her days drawing the ocean, very meticulously, like a photograph. She has turned her back on painting. Firm quietude expressed with a pencil on smooth, gesso-coated paper. The process is endless. One drawing takes Eliza six months of full-time work to complete, with erasure offering the pleasure of beginning again. Eliza's gray ocean—without shore, without vista—water floating in water.

"I like the new slowness, the precision, the lack of spontaneity, the reduced scale," Eliza tells Mary on her first visit to see her down from the Sierras.

To draw, like Eliza, is to constrain, resist, control.

To release.

Eliza's father had scars carved into his face by his family. Such marks of belonging are a Nigerian tradition. Some to denote their royal ancestry. Some to exhibit their livelihood as butchers. Others as signs of shared kinships. Others as fishermen, with distinct marks drawn up to their ears. As a child, Eliza would sit on her father's lap, gazing up at him with reverence, telling him how much she wished that she had the scars too.

"But Eliza, I have these marks on my cheeks because my poor mother had lost three children before me. She believed that each baby was the same spirit baby, an Abiku, coming back, reappearing again only to die, to torment her. So when I was born, my family marked my face so that the Abiku demons who lived in large baobab trees would not recognize me as a spirit mate and take me away again."

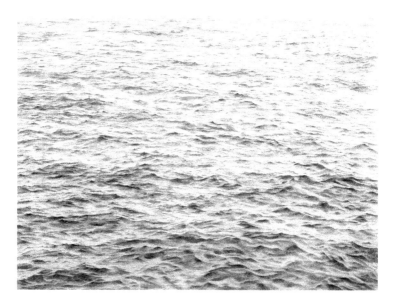

With erasure offering the pleasure of beginning again . . .

"This is not my first sojourn to earth, I have been here before," Banjoko explains as Eliza strokes his face.

"I died three times, and on my fourth return I was given these marks to stop me from returning to the spirit world and to become the father of Eliza."

On the wall above the little dining room table is one of Eliza's ocean drawings, beautifully framed in sanded and oiled soft pine.

"I like saying nothing with the gray ocean," Eliza whispers in Mary's ear as they gaze at this drawing with light, more real than a photograph.

Two days later, Eliza and Mary will return to San Francisco for a couple of nights. And then in the early morning light Eliza will drive Mary in the Karmann Ghia back to Coda's. Eliza will come in to use the bathroom before she heads back to Point Lobos. Mary will make her a tuna salad sandwich on sourdough bread with butter lettuce and sweet pickles. Coda is already out on his boat with its own darkroom that draws its pure water from Lake Tahoe, which he uses for washing the prints. On the side of the boat in very controlled cursive is the boat's name, painted in sepia: *The Floating Zendo*.

Mary is finding Eliza to be generous with understanding or indifference. Maybe they are the same thing.

MARY'S COMPANION LOVER

It's Mary's birthday. Coda has taken Mary to see a litter of Newfoundland puppies. Mary picks out the only one who is brown and white — the only puppy out of nine that is not black and white. His fur is like a dark brown mountain, patterned with snow: like the spectacular view they witnessed on a visit to Mount Shasta. They name him Shasta. Shasta immediately becomes Mary's companion lover.

Coda is taking Shasta for a walk on the shores of Lake Tahoe. He hears a boy's voice exclaim: "It's a Newfie!" The boy cannot control his enthusiasm as he runs screaming to the edge of the lake to give Shasta an adoring smile and a hearty scratch behind the ears. This is to Shasta's liking. Love at first sight.

And if you are able to take your eyes off of Nico (he is such a gorgeous boy), you can see that the Coda is as enchanted with the boy as the ten-year-old-dog enthusiast is with Shasta. Although Nico does not look at Coda, he feels his warm gaze studying him. A gaze that is already planning the pictures that Coda will take of this gorgeous boy until he becomes a man. One, two, three intermittent beats of the heart. Coda is noticing one of the most interesting things about Nico. It's not so much the boy's eyes—his mother's Japanese eyes, blue-black pools sinking up from weeping willow leaves, so different from his Italian father's deep-umber velvety eyes, which appear cushioned— it's Nico's belly button, an "outie," which is unusually shaped. It looks like a tiny cabbage or a rose. Alive as a rose not plucked.

Soon Coda would have his model-boy.

Later, he will lose Nico.

Nico's parents, the sculptor Vera Matsumoto and the architect Renzo Petroni, have invited Mary and Coda over for dinner. Vera and Mary are drinking plum wine over crushed ice. Coda is having a gin with lots of ice cubes. Nico is having a Roy Rogers. Renzo is having a whiskey, neat. Vera is preparing trout sashimi in the kitchen. The males, with their drinks in hand are out in the back garden admiring Renzo's roses and soon will make their way into the shed to admire Renzo's prized 1950 motorbike: a turquoise-blue Triumph Thunderbird. The house is gorgeous and very modern: it was designed by Renzo and is filled with Vera's paper lantern sculptures. When Mary goes looking for the bathroom, she takes a detour into Nico's room.

Drawn to an old Chinese puzzle box made of wood, which is sitting on top of his dresser, Mary discovers the secret to releasing the spring that pops open the little drawer.

FALAPAPA-PAP . . . FALAPAPA-PAP . . .
FALAPAPA-PAP . . . FALAPAPA-PAP

The humble prize inside is an acorn. Mary has always loved the shape and beauty of acorns. The acorn is at home in the palm of Mary's hand—the feeling is irresistible. Like the mouse in Lennie's hand in *Of Mice and Men*. But the acorn is not victim to Mary, as every little mouse was to Lennie. The acorn is not helpless. The acorn is armored, hard: not vulnerable. Inert. Still. With its polished shell—made by a fine cabinet maker—borne in a cup-shaped cupule—fit for Tom Thumb— an ornamental brownie hat of whittled oak: the acorn is alive in its woodiness.

The acorn is a miniature world, a wooden toy: *made of a familiar and poetic substance, which does not sever the child from close contact with the tree.* Nature in its perfection in the palm of her hand. Save for the little hole near the bottom: evidence of the little critter that had once lived inside this acorn.

Stigmata.

When the acorn was soft and green—before the nut became brown and hard—polished like furniture—the little critter's mother deposited her legless grub in the oaknut and left the larva—cream-colored with a teensy brown head—all alone. The little acorn weevil matured in his lonely crèche, living in the dark, feeding off the nut all summer and all fall. The tiny eating machine ate the seed and deprived the world of a mighty oak, one that might have lived five hundred years. One that could easily have become very huge, perhaps eighty to a hundred feet tall, with a trunk more than ten feet in diameter.

One day, the little acorn weevil woke up and opened his miniscule sleepy eyes . . . and chewed . . . leaving a little round exit hole in the night sky of his acorn universe.

He ate himself out of house and home.

He squeezed his way through and began life outside of the nut.

Eating is stealing. A conundrum.

It only takes a minute for Mary to pop the acorn into her skirt pocket.

Mary is waiting. Waiting for Coda.

Waiting is a simple passion.

Mary waits, only as a child can wait.

Mary has given herself over to Coda while hanging on to Eliza.

Eliza has no need to wait for Mary—she is simply there for Mary.

While Mary waits for Coda, she does not want *her mind to concentrate on anything else but the wait itself, in order to not spoil it.*

Mary finds that she can no longer dance.

Mary can only wait for him.

When Mary waits for Coda, there is no present.

After a long night of writing in his journal and developing photographs in his main studio—which has its own large darkroom and a library of books and can be reached by a covered walkway from the back of the house—Coda will come to their bed.

When the morning has turned to light.

Being in the dark and developing pictures makes Coda feel things anew, like a blindfolded lover.

Mary likes to see the sun come up, rising early before the morning turns to light, before Coda makes it to bed. At night, Coda's half of the bed is empty more often than occupied.

But tonight, Coda has come to Mary in their bed, while it is still dark.

Mary feigns sleep.

Seeing the dog, Coda efficiently snaps his fingers, with a clear, sliding click sound. This quietly awakens Shasta, who turns his soft massive head to look obediently at Coda who uses his right index finger to silently, if almost violently, gesture "down, down, down." Shasta, always dutiful, gently slides off the bed, doing his best to monitor his sack-full-of-flour heft. Shasta's departure from the bed is impressively quiet, even with the scraping sound of his dog-paw nails hitting the hardwood floor, save for those curious dewclaws, commonly known

as "dog's thumbs." Tufts of Shasta's brown-and-white fur are left on the bed, a few hairs are caught in the air on the way down, like blown dandelion seeds that smell of big dog. Once the fur has settled, Coda slips in between the sheets. He is naked. He always sleeps naked.

It is 2:00 a.m. Coda's tall angular body fills the absence on his side of the bed. Coda has none of the bulk of someone edging past middle age. Coda looks his age, but is youthful, boyish. He breathes through his mouth. He does not want to smell dog, although he does like the smell of Mary. Mary smells, curiously and impossibly, of Monterey cypress. They have never discussed this fact. He doesn't know the origin of this clean, delicious, deep lemony odor. Mary is turned away from him. He raises his leg over her small body, like an oar one trails in the calm sea. Coda feels the tide of Mary's sleep as full. Mary appears to remain covered by the high seas of profound sleep. Coda remains convinced that he will not run aground on the sand bars of her consciousness. Mary is sheathed in the ivory satin nightgown that she always wears, which is very flattering on her small round bottom. And the thin spaghetti straps make her clavicle bones look so pretty. Mary knows that her clavicle is key to her natural loveliness, hence her taste for spaghetti straps and boat-neck cashmere sweaters.

Coda takes flight with an oscillation like the intermittent wingbeat of a bird asleep in air. The sound of Mary's breathing grows louder, giving the illusion of the panting of sexual pleasure. In her sleep Mary whispers "Eliza, Eliza, Eliza."

Coda feigns an inability to hear.

Sex happens quickly, without penetration.

Coda's eyes shut tight.

Mary's wide open.

Mary has never thought about how the word *clavicle* comes from the Latin *clavicula*, "little key." And she cannot stop thinking about how Coda has never really unlocked her.

To wait is to love.

There are two small populations of the coniferous evergreen tree commonly known as the Monterey cypress. The species is found naturally only on the Central Coast of California, in two small relict families near Carmel. One at Cypress Point in Pebble Beach. The other at Point Lobos. It is said the "Lone Cypress" on Pebble Beach's famous 17-Mile Drive is one of the most photographed trees in North America. Standing on a granite hillside, the evergreen tree is irregular and flat-topped as a result of the strong winds that are typical of the area. The near soilless tree beckons viewers with foliage: heavy masses of tiny scale-like leaves, like a juniper tree, bright green in color. The Lone Cypress reaches out to anyone who looks toward its long fingers.

When the leaves of a Monterey cypress are crushed, they release an intense, deep, lemony aroma.

The male and female cones tend to be separated on the same plant.

The male cones are tiny and yellow in color.

The female cones are larger, but still small, about one inch in diameter: they are shiny and round, with light brown scales.

The female cones give rise to woody fruits, known as strobili, similar to tiny pine cones.

They cluster like Christmas ornaments, or mysterious cocoons, or Paleolithic fertility sculptures, which fit neatly in your palm.

During the peak of the last ice age, it is believed that the Monterey cypress would have had a much larger forest—extending to the continental shelf.

Dramatically sculpted by the dance of the wind, Monterey cypress trees are gnarled and beautiful—like Martha Graham performing *Appalachian Spring*, perhaps for the last time.

Hands like Georgia O'Keefe.

Hands like the wings of a dove.

Hands like love.

Like Nico's grown-man hands.

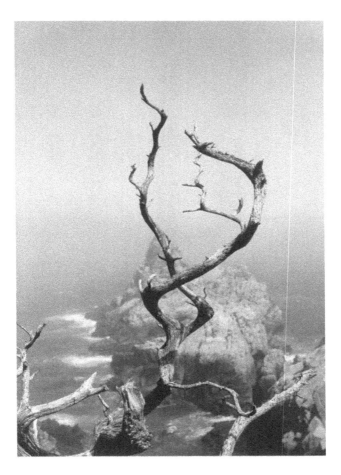

Dramatically sculpted by the dance of the wind, Monterey cypress trees are gnarled and beautiful— like Martha Graham performing *Appalachian Spring*, perhaps for the last time.

Seeking the Zen koan of "the sound of one hand clapping."

Mary's scent of Monterey cypress
is like a drug in Eliza's veins.

In Coda's photograph of his boy grown up.
Seeking the Zen koan of "the sound of one hand clapping."

Mary dabs the essential oil of the Monterey cypress on her pulse points: below her ears—the backs of her wrists—behind her knees.

Mother gave Mary her first bottle of this perfume, for her eighteenth birthday. In the shop, the scent was called Climate. Mother provided her own bottle for the perfumer to fill with the essential oil of Monterey cypress. It was a beautiful old pharmacy bottle of pale-yellow clear glass, tossed and turned by the sand and seawater before Mother had found it on Glass Beach.

A hollow thick flat sphere.

A glass buttermilk biscuit, with a little neck.

Cap gone.

Iced sunshine.

Mary loved the tiny air bubbles in the glass.

After the little bottle was filled with the essence of Monterey cypress—the perfumer stopped it with a perfectly fitted cork.

Mary will refill the same bottle with Climate from the same shop for her entire life.

The perfume lightly hovers in the Point Lobos bungalow, even when Mary is not there.

You cannot see her, but you can smell her.

Mary's scent of Monterey cypress is like a drug in Eliza's veins.

PULLED OUT BY CODA'S HOT LIGHT

Coda and Mary are coating the huge sheet of smooth, hot press watercolor paper with a chemical solution of ferric ammonium citrate and potassium ferricyanide—applying the solution with a sponge, so that there will be no visible brushstrokes. Coda wants the surface to be even, as smooth as possible, like Lake Tahoe on a calm day. He is making the paper sensitive to light. Mary and Coda are making cyanotypes.

In 1843, the botanist Anna Atkins documented her collection of algae with cyanotypes, which float on seas of Prussian blue, like a foam of daisies. Alga is Latin for seaweed. The word may come from *alligo*, which means "to bind to." Atkins placed wet algae directly on the light-sensitized paper and exposed it to sunlight. She made her cyanotypes of British algae into a book. All of the writing—including the book's dedication to her father—is also done in cyanotype: some of the white letters are written with algae, every delicate tendril of infant seaweed imaged with tender care.

> Atkins's algae are *thalasso-graphic*: sea writing.
> Dancing is a form of writing.
> The best writing is dancing.
> Carried by water, like words in a poem.

Coda asks Mary to lie on her side on the big sheets of coated paper—to round her body like a crescent moon. Mary's body becomes an echo of the fisherman's net of woven thick white strings, which has been placed on the coated paper next to her. The net is a discarded amniotic sac from the mythical birth of a sailor's dream. Coda carefully scatters leaves around Mary, like voices to be caught. He lowers a fern over Mary's left breast and onto the paper. A thick long branch of eucalyptus leaves goes over Mary's thigh. Suddenly and without warning, the photo lamp is switched on—Mary feels the hot light shining directly on her pelvis.

Mary falls in love with the light that reaches her from Coda's lamp.

Like the delayed rays of a star.

Coda and Mary rinse the treated paper in the bathtub. Mary's image surfaces on the paper, like white crisp clouds on the surface of a lake on a calm day. A white ghost of herself, naked and exposed.

Pulled out by Coda's hot light.

Paul Ehrlich, an entomologist specializing in butterflies at Stanford University, is on the radio. It's April 1967. Mary and Coda are driving back to Lake Tahoe from San Francisco. They have been to the city to see Trisha Brown dance *Skunk Cabbage, Salt Grass, and Waders*, an improvisation of Brown's childhood memories of duck hunting with her father. As Coda drives through Vacaville, Mary sees pear trees, in full bloom, lining both sides of Interstate 80. Their pure white flowers are so promising, like the dance that she longs to get back to, but can't. And then the shock of the incongruity of the "Nut Tree," announced with a 72 ft tower sign: the spectacularly successful fruit stand turned into a Tivoli-Gardens inspired roadside attraction. Mary had been to the Nut Tree many times as a child. On her visits, she had learned about Sallie Fox, the pioneering girl from Iowa, who had planted a black walnut that she had gathered along the Gila River and dutifully carried in her pocket all the way to California. Planted in the soil of the Vacaville farm that belonged to her aunt and uncle, the tree would grow huge and would famously shade the fruit stand that would give root to a fancy restaurant with glass aviaries for tropical birds, a miniature railroad that took the scenic tour of the grounds from the toy shop to the on-site airstrip, giant rocking horses—all embodied in a playful modernist design (from the buildings to the ubiquitous graphic flowers to the arrangement of the food on the plates). Charles and Ray Eames designed all of the furniture, their molded fiberglass seats were brought to the masses that came to the Nut Tree.

Poisoned by decades of car exhaust, Sallie Fox's walnut tree was felled in 1951. (Others claim a storm killed it in 1952.)

Ehrlich has a confident, prime-time-news voice, coupled with the rhetorical alarm of an Old Testament prophet. The butterfly specialist turned eco-warrior is speaking to the San Francisco's Commonwealth Club on the crisis of overpopulation and its global effect on the starving poor. Mary is shaken by Ehrlich's argument when he says, "Many

people like us consume too much and then there are several billion who don't get to consume enough, and that's one of the many huge problems that are not normally discussed in those terms." Mary feels woozy and empty, even guilty: that same feeling she had as a child, which caused her to not eat. Fed her compulsion to steal.

The radio address is a first draft of what will become *The Population Bomb*, a book cowritten with his wife, Anne Ehrlich—although the publishers insisted on leaving off Anne's name off when the book was first published. The book argues that zero population growth (ZPG) is the only answer to feed the starving people of the world and to preserve the planet's resources. In the hands of the Ehrlichs, famine and ecology are inseparable.

Their book is immediately endorsed by *The Sierra Club*:

> The time is ripe, even dangerously over-ripe, as far as the population control problem is concerned. We shall have to face up or ultimately perish, and what a dreary, stupid, unlovely way to perish, on a ruined globe stripped of its primeval beauty.

In an echo of the slogan printed on T-shirts for those in opposition to U.S. involvement in Vietnam—*Make love not war*—feminists wear T-shirts that read *Make love not babies*.

Also listening to the same radio program on that April day of 1967 is the famed San Francisco-based psychoanalyst Xenia (Zee-nee-uh) Godunova. She is driving home from the Langley Porter Psychiatric Hospital after seeing one of her adolescent patients, who suffers from anorexia and has been admitted this day.

Ehrlich's Commonwealth Club speech spoke to her.

Godunova first developed international recognition through her 1965 lecture entitled "To Eat Is to Steal," where she outlined kleptomania and anorexia as close bedfellows:

> Paradoxically, anorexia and kleptomania are women's mutating mute languages, both of which are forms of fiercely protective speech. Anorexia allows an anarchistic refusal of what one does not want, in some cases nearly everything. Likewise, klepto-

mania allows an anarchistic desire for what one does want, in some cases nearly everything.

To eat is to steal.

TO LOVE IS TO WAIT

Still, Mary cannot dance when she is with Coda.

She has to leave.

Mary asks Coda to destroy the cyanotypes, which contain all the white heat of her pleasure.

Coda obliges her wish.

Coda loves Mary in his own peculiar way.

Eliza is outside in the white Karmann Ghia, waiting.

To love is to wait.

DANCE THAT IS ALL

I live like a plant, I am penetrated by the sun, light, light, color and open air; I eat [dance] that is all.

—Gustave Flaubert

Mary is exhausted, from not dancing. She has lost herself.

Shasta, Eliza, and Mary come through the front door of the Point Lobos bungalow. The white walls honor one more of Eliza's exquisite drawings. It is darker.

Now there are two.

One light.

One dark.

Mary is finding herself again.

In Eliza, with Shasta.

The three of them go to bed together every night.

Eliza does not mind sleeping with Shasta.

Eliza likes sleeping with Mary . . . and Shasta.

It's 1967, the Summer of Love.

Mary devours Marion Milner's *On Not Being Able to Paint*.

Awakened, Mary decides to seek out psychoanalysis.

Time to end the interlude.

Time to dance.

Now there are two.

A SCALE MODEL OF VIETNAM

During the Summer of Love, Chester Anderson, the musician, the acclaimed science fiction writer (author of *The Butterfly Kid*), poet, underground publisher, could be found circulating his own bitter broadsides in the Haight, posted on windows and left in piles. His most famous quote from one of his free-for-the-taking communiqués says this: "Rape is as common as bullshit on Haight Street. Kids are starving on the street. Minds and bodies are being maimed as we watch, a scale model of Vietnam."

TO NOURISH

The butterfly's tongue is a coiled tube like the spring of a clock. If a flower attracts the butterfly, it unrolls its tongue and begins to suck from the calyx. When you place a moist finger in a jar of sugar, can you not already feel the sweetness in your mouth, as if the tip of your finger belonged to your tongue? Well, the butterfly's tongue is no different.

—Manuel Rivas

The etymology of proboscis is *pro* "forth, forward, before" and *bosko* "to feed, to nourish."

THE HALPRINS ARE FRIENDS OF GODUNOVA

When the acclaimed psychoanalyst listened to the radio lecture that Ehrlich gave on overpopulation at the Commonwealth Club of California, it inspired Godunova to expand her psychoanalytic work into the ecological—merging her earlier research on eating disorders and kleptomania with larger environmental and world-hunger concerns. As Godunova quite famously said in her 1968 lecture at UC Berkeley: "Our irresistible tendency to steal things we do not need from the Mother (Earth), is *kleptocratic*."

Anna and Lawrence Halprin attended Godunova's Berkeley lecture, bringing Mary along. Anna had insisted that Mary join them.

As Mary listens to Godunova speak, it is as if she knows Mary, without knowing her.

Mary listens with watery eyes.

Mary listens and wonders how long can we keep mortgaging the birds, the butterflies, the bees, the sea, the children for the future?

By the end of the lecture, Mary knows that she will find a way to secure Xenia Godunova as her analyst.

Mary does.

The Halprins are friends of Godunova.

Mary is twenty-two years old. Mary is finding herself enveloped by a curious courtship between psychoanalysis, feminism, dance, and environmental politics. It's got a hold on her and others living in Northern California.

Alongside Marion Milner's *On Not Being Able to Paint*—and Paul and Anne Ehrlich's *Population Bomb*—Mary reads Rachel Carson's famous cautionary tale about the future of the ecosystem, *Silent Spring*. This book exposes the modern world as a killing field, brought on by the reckless, greedy, thoughtless uses of pesticides. The silent dead birds lost to environmental toxins weigh down the pages of Carson's lyrical yet scientific prose.

Silent Spring is an *Uncle Tom's Cabin* of the environment.

The book's title comes from John Keats's ballad "La Belle Dame sans Merci," where the last line of the first verse comes to our ears without sound: "And no birds sing."

Embracing Godunova's radical philosophies of environmental *antikleptocratism*, Anna and Lawrence collaborate to create *Driftwood City—Community*, an environmental happening performed at Sea Ranch, California, in 1968.

Some of the dancers are dancers. All are volunteers.

There are theater people.

Gardeners.

Cooks.

Painters.

Waitresses.

Bartenders.

Studio assistants.

See Rachel in her red sweater throwing the sand.

Isabel is sitting on Alice's shoulders looking out to the flat gray sea.

Over the sea, Isabel can see silence waiting to be danced.

The theater is the sandy beach. The stage set is made driftwood, sticks, bottles, shells, feathers, flotsam, jetsam, seaweed. The dancers are the audience. The architecture is made of dreams, imagined beings, nothing.

Lizzie in her black bathing suit, her long blond hair traveling down her shoulder, traverses a makeshift bridge of long flat timber. She is a child again, wavering on a balance beam. Two lovers sit at the other end of the bridge, which is now a cliff high above the far-below ocean. White words, like stones, flick tails and move through the air.

A driftwood totem pole is in the way of our vision. It stands like a maypole, its confused dancers moving all around, overwintering like monarch butterflies in Pacific Grove. There are no ribbons.

Out of season.

Out of the frame, Mary is dancing along the shore with Shasta.

Perhaps you can hear Shasta's barks. Perhaps you can smell the sea. But you cannot see Mary.

The dancers are the audience.
The architecture is made of dreams,
imagined beings, nothing.

The sea follows Mary with silver heels.

With Mother's words, lifting and falling—like toy sailboats bobbing.

With her body still and low, Mary hears Mother reading Emily Dickinson aloud...

> I started Early—Took my Dog—
> And visited the Sea—
> The Mermaids in the Basement
> Came out to look at me—

Dickinson, who was very small, had a big Newfoundland dog named Carlo.

One hundred and twenty miles away, one hundred and twenty-seven Black children, from six years old through high school, are dancing at the same time that *Driftwood Community* is happening at community centers scattered throughout the city of Oakland. The young dancers pay $1.00 for a year of dance classes to the Oakland Recreation Department's Division of Modern Dance. It's a vision run by Ruth Beckford, who a decade earlier had limbered up with Merce on Anna's redwood dance deck, while Mary and Melody watched.

In the East Bay they call Ruth the "Mother of Black Dance," or the "Dance Lady."

Earlier this week, Ruth was out helping with the Free Breakfast Program that Bobby Seale, the cofounder of the Black Panther Movement, had begun. He had wisely enlisted the support of the "Mother of Black Dance."

BIG, DROOLING, SHEDDING BEAST

Mary is running with joy in Golden Gate Park with Shasta. It is early morning. Mary is humming with summer in full-throated ease. She has cinched her real silk, threadbare, pearl-gray and oyster-white striped silk pajamas (which used to belong to Mother) with Father's old black leather belt, with new notches punched in. The end of the belt is long and hangs halfway to her knees. Mary has thrown on her ankle-length cocoa-brown Bohemian thin wool coat, embroidered with brightly colored thick yarns of fuchsia-pink, red, orange, gray-blue, cornflower blue, red, white, and olive green in patterns inspired by folk-art weaving.

- Diamonds
- Sergeant stripes
- Tulips
- Turtles
- Suns
- Moons
- Carnations
- Irises
- Vines
- Pomegranates

The collar and the wide cuffs are made of black rabbit fur (which Mary finds equally disturbing and delightful). The lining is passion fruit–pink silk. Mary bought this coat with an appetite for Eliza's cherry blossom–pink lined kimono.

Shasta has nearly taken up permanent residency in Golden Gate Park. Mary causes quite a sensation when she takes her enormous Shasta for walks in Golden Gate Park around Stow Lake, the Japanese Tea Garden with its moon bridge, Rainbow Falls, the Dutch and Murphy Windmills, and the Buffalo Paddock. While playing with her New-

foundland, Mary recalls how Shasta used to stand on his hind legs and box with Coda.

Shasta and Mary have had a long romp in the park. They are now heading off in the Karmann Ghia to Xenia's office. Shasta is in the front seat. Today it is warm enough to have the convertible top rolled down. Xenia likes dogs. So Mary always arrives with her big, drooling, shedding beast.

THE SAME DEEP THOUGHT

Concepts can never be presented to me merely, they must be knitted into the structure of my being, and this can only be done through my own activity.

—M. P. Follet, as quoted by Marion Miller, *On Not Being Able to Paint*

Xenia knits during her appointments with Mary.
 Mary was always surprised about the needles.
 Crossing.
 Like the first letter of Xenia's name.

 CLANK, CLATTER, CLASH, CLANG, KNOCK, CLINK, KNIT

 Listening to the sound of the bone needles clacking together, tapping, dancing. Like the gentle clicking beak of a blue jay. Bony birdly sounds going nowhere.
 Xenia explains to Mary that knitting ensures that she does not make any gestures or expressions that her patients will respond to with their own reactive movements—comments—hesitations—silences, which inevitably become part of their telling stories. Knitting helps to neutralize the playing field between doctor and patient. And it relieves both of the burden of eye contact. Xenia's patients sit in a comfortable chair—they do not lie down—thereby foregoing the eroticization of the analysand held horizontal on the "Freudian" couch.
 Although Mary does wish that Xenia had something to lie down on. Lying down invites dreaming—*flying into the unconscious on a magical carpet, like the Persian rug that Freud draped over his therapy couch, which sighs with* The Arabian Nights.
 Mary, though, would not like an Orientalist setting—she would like a plain and simple bed with walls that she might draw upon as she

did when she was a child. A bed that would leave an imprint from the weight of her body and from Xenia's other analysands (whom Mary sees, if at all, only in the waiting room). A bed where stories once told are indexically traced, held, in an ascetic mattress. Wear and tear as testimony to letting go.

Speech, like the past, has its own weight.

Xenia's knitting practice takes its yarn from the psychoanalyst Marion Milner, a writer as well as a psychoanalyst. *On Not Being Able to Paint* emphasizes the process of the act of creativity rather than the final creation. Milner focuses not on the achievement of genius but rather on foregoing what restricts our creativity. Milner encourages practitioners "to accept chaos as a temporary stage" and to "plunge into no-differentiation," to let go, without fear.

When Xenia knits, it is all process. Xenia knits toward something unknown: she is not in reach of a beautiful sweater, a perfect blanket, something finished.

Xenia explains to Mary that her kleptomania and anorexia are one in the same thing: are inseparable. Pointing out that Mary's desire to steal personal objects from others and her refusal to eat, are both mutually reinforcing psychoses based on a familiar childhood anxiety: the desire to break into the mother's body.

To which Mary asks: "In order to find what, some golden eggs?"

While remaining focused on her knitting, Xenia replies with a bit of a laugh: "Well sort of. Early in their development, children feel that their mother's bodily contents (her feces and her feces-turned-into-babies) are endowed with magical powers. Children often have a desire to steal from Mother's insides: her heart, her waste, her blood. And to consume them, eat them."

"And eat them?" Mary asks.

"Well, perhaps more magically (or metaphorically) than literally," Xenia explains, already ten rows ahead in her knitting. "Psychoanalytically speaking, these are the views of Melanie Klein, which echo those

of Karl Abraham on the 'oral fixation,' in which loving somebody is exactly the same as the idea of eating something good."

"I am sure that I never wanted to eat my mother," Mary whispers back to Xenia, just loud enough to be audible over the click-clack of her needles hard at work.

Mary shifts the conversation to dance. Mary tells Xenia that her brain feels clean when she is dancing. A feeling that that she first experienced when she was child in the woods with her friend Aaron, before she stopped eating. Mary tells her about the experience—the green caterpillar on her neck—the smell of Aaron's sweat, like young garlic—his freckles like burnt toast.

Mary tells Xenia about the last time she saw Aaron and the disappointment for both of them. The sea-beaten heart of red glass.

"Mary," Xenia asks, "why haven't you mentioned Aaron before? What happened to him?"

"I don't know," Mary replies. "I never saw him after high school. He went to Vietnam. And that was the last I heard of him."

Mary cannot talk about Aaron with Xenia. Aaron is a kernel lodged inside her shell. Mary has swallowed Aaron. Mary has to keep him there. Take care of him. *No exit wound to the sky.*

CLANK, CLATTER, CLASH, CLANG, KNOCK, CLINK, KNIT

"Okay Mary, I will see you next week. Same time."

And out Mary walks with Shasta, taller than her waist. The dog and the dancer seemingly sharing the same deep thought.

THE KNITTING IS SO TENDER

Xenia's knitting "actions" are Melanie Klein–inflected reparative gestures—aimed at cure, which is never far from care.

Xenia knits for the bird that occupies Mary's breast.

> FALAPAPA-PAP . . . FALAPAPA-PAP . . .
> FALAPAPA-PAP . . . FALAPAPA-PAP

Never-finished, only imagined, garments for Mary's bird hungry with desire, in pursuit of some sort of liberation. An avian creature that, according to nature's law, usually keeps to its own flock but has inhabited Mary's heart.

Xenia knits make-believe miniature capes, mittens, and mufflers for Mary's bird.

The knitting is so tender.

Once on a bus, Mary saw a young man with warm eyes pull from his bag a pair of metal knitting needles and then began to knit. The knitting fell from his needles into a puddle of knitted blue. Did he, like Xenia, have a preference for cerulean yarns? He knitted absentmindedly. As if he were going nowhere. The nail of his middle finger, a shorter nail, was painted deep carmine. An erotic sign. Only that one finger. The scene was scandalous. Not so much because conventions forbid men to knit. Not so much because of the carmine-painted nail. But that it represented a beautiful and *successful idleness* on a bus going down Haight Street.

NO STRINGS

Mary sees Xavier in the audience.
 Eliza is standing next to Xavier.
 Mary catches Xavier's eye.
 Mary does not catch Eliza's eye.

Xavier is leaning against the gallery wall. The adorable, slightly troubled face. His uncanny, watery, sea-lion eyes. The long black lashes, which Mary can see even at a distance.

Heat right between her clavicles.

Heat in her cheeks.

Mary finds herself moving stronger, more fluidly. Mary is more alive. Mary is moving for him. Only him.

Mary is one of six dancers performing Simone Forti's *Huddle* at the San Francisco Dancer's Workshop. Moving and holding still. Unfolding slowly and refolding slowly. For the ten-minute duration of the dance, bodies organizing and reorganizing—separating and coming together. Climbing over each other. Slowing time down. They are a decelerating knot of bees, laden with the heft of honey. They are laden with holding the weight of each other. They are laden with the weight of the moment. A mountain that moves. A bumbling beast.

Mary climbs over other bodies and looks into Xavier's eyes. The eyes of Xavier Castro Pacheco.

Those sea-lion eyes with long black lashes—manatee—queen conches—Quintana Roo—cenote—now more watery with age.

Xavier is a musician.

As a ten-year-old boy, Xavier was fierce about Guty Cárdenas and learned to play guitar like his hero.

Augusto Alejandro Cárdenas Pinelo, nicknamed Guty, was from Mérida and played a kind of music called Yucatecan trova, a style cre-

ated by the poets. Soaked in rich romanticism, Yucatecan trova combines lyrical poetry with the sensual rhythms of the Caribbean.

The Boy Xavier was drawn to the sound.

The Boy Xavier was enamored of the fact that Guty was murdered by a stray bullet in Mexico City at the age of twenty-seven.

It was so strange to hear the words of "Nunca" (Never) coming out of the boy's lips while he strummed a guitar — too large for his childish body:

> *Yo sé que nunca*
> *besaré tu boca,*
> *tu boca de púrpura encendida,*
> *yo sé que nunca,*
> *llegaré a la loca*
> *y apasionada fuente de tu vida.*

> I know I'll never
> kiss your mouth
> your ardent purple mouth
> I know I'll never
> arrive to the crazy
> and passionate source of your life.

At night, the Boy Xavier slept with his guitar. Careful to never roll over it.

Xavier.

Ha-vee-air is how he says his name, like a breath of air.

Ha-vee-air is how his mother and father pronounced his name while he was growing up in Tulum.

Some say *Sa-vee-air*.

Some say *Sha-vee-air*.

In France, they say *Zev-yay*, pronouncing the two crossed knitting needles of "X," like the "Z" of Xenia.

With little English and a scholarship to the San Francisco Conservatory of Music, eighteen-year-old Xavier found himself in California. While at the conservatory, Xavier continued with the acoustic guitar,

took up the cello and went back to guitar, struggled with English, fell in love with the Pacific, became swept up in the poetics of the San Francisco Renaissance, and resolved to become a composer. He went on to Mills College for graduate work and met the rhythmically obsessed Steve Reich as a fellow student.

In Pauline Oliveros's living room, he watched the future developer of deep listening and radical postwar electronic music grasp her Roland V accordion—as if in a recall of Leonardo's reverberating, huge, quivering, reaching, moving drawing of *The Virgin and Saint Anne*. A seance of a sketch. If not consciously so, Pauline redrew Leonardo's life-size cartoon—not with charcoal and wash, highlighted with white chalk on eight large sheets of paper, but rather with sound.

A reproduction of Leonardo's drawing of *The Virgin and Saint Anne* was hung in the dining room of Xavier's grandmother's house. He stared at it for all of his childhood.

Pauline is Saint Anne with deep-set eyes.

Weighty.

Alice B. Toklas handsome.

Pauline's accordion is the hefty Virgin, glad to be sitting on Oliveros's lap.

The word seance comes from the French word for "session," from the Old French *seoir*, "to sit."

A wheel of smiles.

The shrieks, rumbles, and reverberations of the accordion are absorbed fully by Pauline's body—the fingers of her right hand run like spider's legs. At one point Xavier sees Pauline stop and point to the heavens with the index finger of her left hand. Xavier sees Pauline and her accordion as the unspoken and abandoned territories of sex. But no one else sees it that way.

Xavier took up the abstraction of contemporary postwar experimental music, without giving up his nostalgia and reverence for Yucatecan trova.

Yucatec Maya is strung alongside English.

Xavier's poetic voice contemplates both the sound of a word and its various meanings.

Pauline redrew Leonardo's life-size cartoon—not with charcoal and wash, highlighted with white chalk on eight large sheets of paper, but rather with sound.

Sense is shifted.

Ungrounded.

Irony becomes indeterminate.

Xavier is fond of acoustic slaps on the body of the guitar. In his "Hymn to the Belly Bowl of the Chacmool," Xavier incorporates an electronic speaker inside one of his guitars, which plays the voice of a woman singing, without beginning or end. Xavier sings a duet with her. The speaker inside his guitar is engineered to begin when he places the guitar on his lap and to stop when he puts the guitar down on the floor.

Xavier considers his guitars as the unspoken and abandoned territories of sex.

His followers see it that way too.

In "Hymn to the Manatee," Xavier plays his guitar with exquisite slowness.

In his "Hymn to the Melipona Bee," he slaps the belly of the guitar in swarming and soothing rhythm. No strings.

Mary has not seen Xavier for eight years. Not since she was fifteen, skiing with some older friends in Crested Butte, Colorado.

She met him while catching one of the last lifts of the day. Her friends were in the lodge, drinking, eating, getting warm. The sun was beginning to set, so the air was even colder. But it was still crowded. The snow was blue with shadows.

Since Mary is alone, she is expected to find a partner to join her on the ski lift's double chairs. A single riding alone in a double chair is discouraged, since this will slow down the line. Mary shyly, but loudly, calls "Single!"—as is the protocol for pairing up.

Upon hearing fifteen-year-old Mary, Xavier Pacheco, a musician from the Yucatán Peninsula, echoes back with his own clear, confident, masculine "Single!"—all the while quickly marching forward to her, although encumbered by his long black metal "Head" 360 skis with Marker step-in bindings. *HEAD* is written dramatically in yellow, in an edgy slant at the top of his skis.

Xavier reaches Mary near the front of the line where she is self-consciously waiting on her shorter mogul-hopping red-white-and-blue K2 fiberglass skis, with step-in Solomon bindings.

Mary meets his gaze.

"Hi," says Mary, with a small smile.

"Hi," Xavier replies, his eyes full of sparkle, his lips almost hidden by a neatly trimmed frozen mustache and beard. His smile is bright and enthusiastic. Xavier is not the least self-conscious. He is twelve years older than Mary.

Sitting on the lift chair, side by side, Mary feels his bodily warmth. This man, this older man, this man so much older than Mary, reveals to her that he is twenty-seven, that he is from the city of Tulum in the Mexican state of Quintana Roo on the Yucatán Peninsula—explaining to Mary that it borders on Central America. "I am from a very warm place."

Mary says nothing. Just smiles. Just looks into his eyes.

Mary colors like the fifteen-year-old girl that she is.

Between them—polar breath-clouds—breath made visible by a temperature so white-cold that it is hard to hear—even a bit difficult to breathe.

Glacial dandelions.

Proof of life.

Looking up ahead, Mary sees each chair making its wibbly-wobbly skyward journey with pairs of skiers—some meeting each other for the first time. Mary and Xavier are not the only ones.

Xavier continues to talk.

"The beautiful town of my childhood has miles of cenotes everywhere: stunning underground limestone swimming pools, filled with fresh, crystalline water. Some are deep-water shafts with vertical walls. Some are semi-open. Some are entirely open and appear like a lake or a river. The word 'cenote' is derived from the Maya *dz'onot*, 'well.'

"The most magical cenotes are entirely cavernous and can be reached only through holes in the ceiling, with dangerous ladders or stairs. Once inside, rays of light slash their way through the aperture of the cenote. Once your eyes adjust to the new darkness lit from the hole above, one sees the walls of mineral stalactites and stalagmites glowing violet-blue. A large turquoise swimming pool of crystal-clear water awaits you.

"The Yucatán Peninsula is mainly limestone, and the porous bedrock does not allow for freshwater to accumulate into rivers and lakes—instead it drains this water through perforations and collects it underground. When the bedrock destabilizes too much, it collapses and reveals a big blue, blue-green or green eye of water. This is how a cenote is born."

In a directive that is condescending, irresistible, charming—Xavier tries to teach Mary to pronounce cenote:

"Say '*say-no-tay*.'"

Mary smiles and refuses to speak.

He accepts Mary's annoyance with a slow nod and an understanding sweet upside-down smile.

"How about saying my name?"

He grins broadly, knowing she never will.

"Xavier," he says with a gently laugh.

"*Ha-vee-air* is how my mother and father pronounced it.

"Some say *Sa-vee-air*.

"Others say *Sha-vee-air*.

"In France, they say *Zev-yay*."

Mary will not say his name. But she does smile broadly, and Xavier is moved by her childish teeth, even and white, bared by her lips as proof of a perfect skull, her immaculate soul.

He learns, suitably, that her name is Mary.

Xavier continues his geological lecture, with his intriguing Mayan accent—with its hard, quick consonant sounds.

Mary yearns to ask him about swimming in the blue and green waters of the cenotes, but she can't. She's awestruck with Xavier and his hard-hitting *k* sounds. Her heart races—she can hear it beat in her silence. Mary colors like a fifteen-year-old girl.

She is a fifteen-year-old girl.

Is innocence just one of the disguises of beauty?

Plump white snowflakes fall soundlessly from the sky. It's cold on the ski chair floating as high as the tall trees. Mary takes off her right glove and sucks on her fingers to warm them in her mouth, like she did as a child. Her gentle trepidation makes the act more erotic.

A pink cherry blossom in the snow at first bloom.

He tells her that he has lived in San Francisco since he was eighteen.

She tells him that she lives there too, that she was born in San Francisco.

Sleeping with Xavier is liberty for Mary, even though she is so young and inexperienced. She is uninhibited about her body. Xavier's crush on her girlish form stops her from being discommoded by it. She feels an intimacy with Xavier's Quintana Roo childhood. Where girls also have very big eyes. Where girls are also not so tall—but are also very

unlike Mary: with their strong wrists, ample breasts and hips, and long thick black hair. Xavier tells her that he likes her "boyish" brunette hair. And queries: "Did you not eat as a child?" Commenting: "You seemed to have not grown up." But with a smile.

Mary is an unreachable country reached.

Mary had already had her tenderness with Aaron, but Mary had never had sex before. Although she thought about it all of the time. She wanted to taste it.

Circles of time, different aspects of water, snow, ice. Some crystals appear as sparkling white flowers. Mary reaches forward for the pretty ice flowers, to catch them like snowflakes on her aroused tongue, unable to keep them from melting.

> Hold on.
> Pleasure-pain.
> Nakedness.
> Kicked out.
> Eyes shut.
> Eyes wide open.
> Voice torn off.
> Blood caul.
> Brain wiped clean.
> Black unknown penetration.
> Sea shattering.
> A far sea moves in her ear.
> Pink light.
> Like a snail.
> Oozy, sweet, amber fragrant honey.
> Wet eyes.
> Animal wanting.
> Plant purpose.
> Indifference.
> Moon on her forehead.

Fragile butterfly.
Spidery unsafe.
Glassy light.
Death wish.
Dance.
Smiles caught.
Something new sleeps in Mary.

But Xavier was disappointed not to smell—on the tips of Mary's fingers—the impermeable scent infused into the hands of the girls (and women) of Quintana Roo: cilantro, Melipona bee honey, chile habanero, smoked venison.

Melipona bees, indigenous to the Yucatán Peninsula, are stingless bees. They have been kept by the lowland Maya for thousands of years. They have no stinger, but they will bite with their mouths to protect their hives. In nature they are found in tree trunks and hollow logs. Melipona bees are smaller than European and American bees. They yield far less honey.

Melipona honey has a long aftertaste.

It is said to aid with cataracts and childbirth.

After the sex, Xavier talks.

"I want to show you Casa Cenote, which some call Cenote Manatee, after the manatees who used to swim there so long ago."

Mary is not sure what a manatee looks like. Perhaps like Eugenie?

"At Casa Cenote, the water is not fresh, as it usually is in the thousand and one cenotes of my country—it is a mixture of sea water and cool fresh water.

"And I will take you to Cenote Jardin del Eden—to bathe you in its fresh turquoise-blue water.

"At Cenote Jardin del Eden you will drink its pure water—so you will never lose the adolescence of you.

"You are a Yucátan *oon* (*aguacate*). You taste like butter. The large seed has been lifted from the beechnut of your smooth armpits."

"I am Maya," Xavier tells Mary.

"Yucatecos like me speak Maya."

In their encounter in the Rocky Mountains of Colorado, Xavier stockpiled his youth in heaps of black curls.

No phone numbers were exchanged.

They never saw each other again.

Until 1969.

Now Xavier's curls shimmer with thick, a bit too early, threads of silver.

Nevertheless, Xavier is blessed with some kind of eternal youth, which is most apprehensible in the shimmer cast from each of his dark pupils—each one like Venus.

Visible stars, even when the sun is up.

SOMETHING BEGINS

Now it is 1969. The day after the performance of *Huddle*, Xavier appears again, again out of the blue, this time on a green bicycle. Eliza and Mary have just walked out of the de Young Museum in Golden Gate Park—and there he appears on a green bicycle built for three. Mary has never seen a bicycle with three seats before. Mary notices that it is German, but she does not ask questions.

"Wanna ride?" he asks, speaking with his infinitely sad and sweet wet eyes. His Yucatecan accent holds the far-off lament of a sea lion on the shore next to a calm gray sea.

Mary accepts the ride. And so does Eliza. Mary sits right behind Xavier. She is wearing a summer dress of light blue linen, with spaghetti straps and black grosgrain ribbon at the waist, which adds to Mary's feeling of having everything that she had imagined that she ever wanted. An hour like this in a summer dress. Behind Mary is Eliza.

Mary and Eliza peddle along, but it is Xavier's strong legs pumping up and down that truly propel them. Xavier pedals them all around the park. Mary's eyes are wide open.

And Mary experiences an involuntary memory: Father teaching her to ride a bicycle, when was five. Pushing her away. Setting her free.

Riding blind.

Without a plan.

A mystical dream episode.

Chance encounters.

Mary's body is open to extravagant joy and discovery.

Mary experiences liberty with Xavier, again.

The scene stings with eroticism. Riding a bicycle while wearing a thin dress makes Mary feel vulnerable and gives her pleasure—Simone in Bataille's *Story of the Eye*—but only a pinprick of Simone, for Mary is not wearing stockings and she is wearing underwear.

Furiously wild. A violence. Grinning. The brutal excitement of

Willem de Kooning's wild abstract expressionist painting *Woman and a Bicycle*. Grinning.

Mary feels the niggle of the seat behind her where Eliza sits and pedals. Proust's Albertine and the secrets of her bicycle rides with her lesbian "band of girls."

The three ride into the blue.

Now it is night. Xavier and Mary are together in bed. Mary listens to his ridiculous love phrases in the coolness of their Art Deco motel, two blocks from the sand dunes of Ocean Beach.

In the dark, they are crying out to each other in the bedroom.

Or is it the sound of the seals on Seal Rocks, near the Cliff House and the Sutro Baths?

Out comes his song, warm on his pinniped breath.

Xavier does not speak much. Mary likes this. And she likes what very little he is saying. All the ridiculous words. Where has she heard them before?

"Your breasts are undersea molehills of the night."

"Your mouth has the fragrance of a star."

"Your temples are greenhouse windows, with steam on the windows and pink begonias inside."

"Your armpits are resting places for sea snails."

While Mary sleeps, Xavier looks at her. Xavier continues looking at Mary with his eyes closed. He inhales Mary's Monterey cypress-scented neck, with its deep lemony odor and is flashed a memory of Melipona honey, which has more of a citrus flavor than European or American honey.

He feels Mary's body as unfinished, without artifice, of the moment, without future plans.

He takes Mary *as he would take his own child. He takes his own child the same way. He plays with Mary, his child's body, turns it over, covers her face with his lips, his eyes. And Mary goes on abandoning herself exactly the same way as if it was the first time.*

Mary is drawn into his uncanny, watery, sea lion eyes.

And the fact that Xavier's highly manicured nails are polished with a clear lacquer.

Mary caresses the folds of his older skin, like a coffee-colored Fortuny gown made of silk.

Mary cherishes something feminine about Xavier. Interiorized.

How remarkable Xavier's hunger for sex is.

Mary loves the feel of Xavier's soft, loose skin.

His paternal delight in the youth of her body.

The thick threads of silver through his thick black curls.

Into her pocket, Mary slips a tiny volume of *The Songs of Dzitbalché* bound in green leather, which Xavier had left on the bedside table. The title is stamped in gold. The edges of the pages are gilded gold. Gertrude Stein *Tender Buttons* shine. Mary understands nothing of this Mayan tongue.

> *Bin in tz'uutz' a chi*
> *Tut yam x cohl*
> *X ciichpam zac*
> *Y an y an a u ahal.*

> I will kiss your mouth
> between the plants of the milpa.
> Shimmering beauty,
> you have to hurry.

Mary plucks four and twenty blackbirds from the sky and puts them in a pocket-envelope-pie. Something begins.

MARY SEES A BABY'S FACE IN THE WAVES

Like salmon full of roe laden with the moment.
Mary sees a baby's face in the waves.

Mary sees a baby's face in the waves.

Mary is living between places.
 San Francisco and Point Lobos.
 Mary is living between lovers.
 Xavier and Eliza.
 But never without unquestioning Shasta.

At the wedding, there are seven.
 Mary.
 Xavier.
 Melody and Ray.
 Eliza.
 Shasta.
 The little baby inside Mary.
 It's not a legal wedding, but it is meaningful.
 The seven are some sort of a family.
 Living is an experience.
 An experiment.
 For the ceremony, Mary wears a thin, delicate tiara and a white silk vintage gown from the twenties. It shows off Mary's clavicles, each one *curved as a dolphin bone held in the sea.*

ELIZA SAYS HER SORROW IS SO GREAT THAT THE MOUNTAINS CHANGED PLACES AND BEGAN TO LEAK MILK

Eliza does not mind how Xavier lets Mary smell the fragrance of his cherished beard. It smells of cilantro, Melipona bee honey, chile habanero, smoked venison. Or how he tells Mary that he loves her while brushing flakes of *sáak'* (cigar) ash out of his beard. And how Mary loves that gesture more than his words. How Xavier rubs his beard against Mary's cheek to speak what he cannot say. How Mary finds his emotional indifference (combined with his sexual prowess) towards her irresistible.

And even Eliza is drawn into his uncanny watery eyes.

And the fact that his highly manicured nails are polished with a clear lacquer.

And if Eliza knew, she would not mind how Mary caresses the folds of his skin, like a coffee-colored Fortuny gown. Or how Mary cherishes something feminine about Xavier, something interiorized. Or how remarkable Xavier's hunger for sex with Mary is. Or Xavier's paternal delight in the youth of Mary's body. Or how Mary fingers the thick threads of silver through Xavier's thick black curls.

Eliza does not mind that Mary married Xavier.

And Xavier does not mind Mary's love for Eliza. He enjoys thinking about it and often does.

But Eliza does mind the baby.

Eliza says her sorrow is so great that the mountains changed places. And began to leak milk.

Eliza says her sorrow is so great
that the mountains changed places.
And began to leak milk.

OCEAN'S TIME

Eliza stops noticing the pencil. Eliza is no longer married to drawing. Eliza no longer draws the ocean: she makes large, colorful cyanotypes with the Pacific Ocean.

She begins by hand-coating cyanotype emulsion (mostly iron salts) onto giant sheets of paper.

With the help of Mary, she then introduces the cumbersome coated giant sheet of paper into the waves of the Pacific Ocean.

The movement of the waves pulls the chemicals across the prints.

Eliza's images are the movement of Ocean, its sand, its seaweed.

Eliza leaves the cyanotypes unfixed, so that even on the wall they continue to change.

To move.

Eliza signs each of the prints in soft dark pencil in her wavy cursive with her name and the phrase "Taken from Ocean on," along with the date in which it was made.

Ocean likes to make things with chance.

She sees beauty as accidental.

Loss of control is Ocean's method.

This new affair of Eliza's with Ocean is terrifying, exhilarating, reckless.

Yet, Ocean can be so sea-soft.

These *"fugitive cyanotypes are analogies for a terrifyingly fleeting and beautiful existence."*

The shadows, the sand smears, the bubbles, all the liquid dancing souls left on the huge sheets of archival paper—are Ocean's alone. They are Ocean's own colors: aquamarine blue; ultramarine blue; crab-shell blue; squid-ink black; sea-anemone violet; seaweed brown-blue; abalone-shell cerulean-pink; California-gold-sea-hare indigo.

Eliza no longer dreams in drawing.

The shadows, the sand smears, the bubbles, all the liquid dancing souls left on the huge sheets of archival paper— are Ocean's alone.

She dreams Ocean.
Ocean's temperature.
Ocean's salt.
Ocean's slime.
Ocean's time.

Mary begins to feel flutters from this tiny creature who floats inside her, with gill-like folds called pharyngeal arches.

The baby grows.

The movement grows.

Mary has a terrible nightmare.

Somehow, Mary has tied a string around the little one in her womb, whose dancing wakes her up at night. Sitting in Father's overstuffed chair, reupholstered in a Sanganeri cotton print of blue elephants, Mary's eyes are turned to the sky, and she is pulling the baby up through her body, by way of a magical, nonsensical string—umbilical cord and all. With great difficulty, the baby moves past the air pillows of Mary's lungs and the thumping of her beating heart. With painstaking slowness, Mary continues to pull on the string. The infant moves into Mary's stretched open throat. The baby's head begins to emerge from Mary's overly widened mouth. The baby's head, covered in black hair, soon comes into view. It looks as if Mary is trying to swallow the baby, rather than get her out. Breathing is difficult and can only be done through her nose. Mary reaches upward and grasps the baby's chest and pulls her out. She gets the baby out. Holding the baby in her arms, Mary finds a pair of scissors: she carefully cuts the umbilical cord. The string for pulling the baby out has vanished. Blood everywhere.

NOTHING INSIDE OF MARY

The human

heart is told

Of nothing —

"Nothing" is

the force

That renovates

the World —

— Emily Dickinson

And then, unexpectedly, like the surprise of a large rogue wave in the calm, flat sea — Mary found a bloody stain in her underpants.

Soon there would be nothing inside of Mary.

NO SONG

The little baby is out.
 No handful of notes.
 No clear vowels rise like balloons.
 She was not ready to come out.
 No song.

IS THIS WHAT YOU WANTED?

Mary is full of guilt.

Perhaps she willed it—the loss of the baby. Made it happen. But having the baby would have brought pangs of deep guilt too.

Eliza tries to hide her relief, which verges on joy.

Even with the guilt, Mary (too) has to hide her relief, which verges on joy.

Xavier asks, before he drifts away forever: "Maybe this is what you needed?"

Melody tells her: "It has nothing to do with you."

Xenia asks: "Is this what you wanted?"

THAT DARK INVOLVEMENT WITH BLOOD AND BIRTH AND DEATH

All one's actual apprehension of what it is like to be a woman, the irreconcilable difference of it—that sense of living one's deepest life underwater, that dark involvement with blood and birth and death.

—Joan Didion, *The White Album*

THAT WHITE FEATHER FLOATING ON TOP OF THE SEA

Mary is with Eliza at La Jolla Cove snorkeling in Southern California's warm water. Their diving masks make the already clear water even clearer. Under the sea, bubbles come from their snorkel-holding mouths.

They *blow like kisses and are blown back.*

The bright orange clownfish with their white stripes are real and impossible.

The sea is soft, as if it were treated with exotic salts.

There is a renewed innocence to their erotic floating about, now that Xavier has drifted away entirely, so politely.

Above them, they see a fuzzy white feather floating on top of the sea: the blue sky is its background.

A psychic will tell you that lost loved ones will reach out to you through the thin wall between the living and the dead with signs.

Is it Aaron?

The little baby?

Let's say it's both—that white feather floating on top of the sea.

WHAT HAPPENED?

It's been a long time since we first met Mary *en-caul*.
I recall.
What happened.
In a rush, like aging and the way things speed up.
Was that a decade ago?
Not last night?
But the night before?
The libretto of life.
(*Libretto*: a borrowing from Italian, meaning "little book.")
Life.
Flashes.
Grateful Dead Invite You to a Dance Celebrating Mainly All of Us 1966—Yvonne Rainer dances *The Bells* 1961—Black leotard with zipper 1954—Bay of Pigs Invasion 1961—Merce Cunningham leaps across Anna Halprin's deck for dancing 1957—Marion Morgan Dancers are featured nude in the *Los Angeles Times* 1920—Rachel Carson publishes *Silent Spring* 1962—Alfred Hitchcock's *The Birds* 1963—Nat King Cole records "Nature Boy" 1948—Eutropheon, a health food restaurant, opens in Laurel Canyon 1941—"Norwegian Wood (This Bird Has Flown)" 1965—Eliza Vesper sees the Pacific Ocean for the first time 1966—Alcatraz is occupied by Native Americans for more than nineteen months 1969—Simone Forti *Sleepwalkers/Zoo Mantras: Dance Constructions Retrospective*, L'Attico Gallery, Rome, 1968—Coda Gray builds his floating darkroom boat, *The Floating Zendo,* and launches it on Lake Tahoe 1964—Anna and Lawrence Halprin's collaborative ecological piece: *Driftwood City—Community*, Sea Ranch, California, 1968—Neil Armstrong and Edwin "Buzz" Aldrin land on the moon's Sea of Tranquility and take a walk 1969—*Rosemary's Baby* 1968—Martin Luther King is shot 1968—the pill is approved by the Food and Drug Administration 1960—birth control is made legal for all married women by the U.S. Supreme Court 1965—César Chávez, the gardener/organizer,

César Chávez, a vegan gardener/organizer . . . breaks his twenty-five-day fast by accepting a piece of bread from Bobby Kennedy 1968.

a vegan who fought for the rights of grape pickers, who made eating grapes and having a lettuce salad a political crime, breaks his twenty-five-day fast by accepting a piece of bread from Bobby Kennedy 1968.
 What happened?

WOULD SOMETHING ELSE HAVE HAPPENED?

Minutes before Bobby Kennedy is shot at the Ambassador Hotel on June 6, 1968, he looks into the eyes of others, relaxed, happy. He has just declared victory in the California primary for the presidential race.

Hope. Alive, he can still look into the eyes of others.

As a joke, he says, "We've been here too long."

What if he had stayed longer?

Would something else have happened?

It's been many years since we first peered into Mary's glass egg, still soft at the end of the glass blower's straw. We saw the pale blue-blue twisted rubber licorice umbilical cord wrapped around Mary's face, just below her still-closed, long-slit-eyes. Mary was not ready to open her eyes, not yet.

Gloved fingers gently tore the slimy casing. A sea of water was gently released.

You will remember that Mary was an anorexic child and that Father, somewhat blind to the devastation at hand, gave Mary the affectionate nickname of Theco: short for Thecosomata—the scientific name for a type of sea butterfly. "Theco" is also intimately close to Father's name of "Theo," short for Theophilus.

Thecosomata are free-swimming sea snails, popularly known as sea butterflies, that live in the open waters of the ocean, not on the seafloor. Many have shells so fine that they are transparent. No bones. They seem to be made of nothing at all.

The sea butterfly moves between plant, animal, and water.

In *Happening*, Mary's quietly celebrated dance of 2000, she imagines herself as christened again—this time self-christened as a sea butterfly.

For *Happening*, Mary transports Anna's dendrophilia into the sea: thalassophilia.

Mary flutters out of her body to become one with the sea.
Dancing with two winglike lobes, with slow flapping movements.
A tiny echo of Loie Fuller.
Dancing.
Dancing as happening.
Like the movement of the Sufis, seeking orientation in disorientation.
An experience that dances you to the edge of your being.
Like a desire to become one with God.

Like denouncing all forms of materiality.
Out of the materiality of your body.
Dancing immaterial existence.

In Mary's mind is the fact that the sea butterfly, so sensitive, faces extinction and, in turn, so will she—and, perhaps, so will the sea that feeds off these sea butterflies.

Happening is very different from Mary's free-spirited, torso-twisting, arm-swirling gambits of *Caul*. But no less beautiful.

In 2020, when Mary was well into her seventies, she wrote on a scrap of paper, "'It has not been a successful life—only a beautiful one.'" These words are from Henry James's *Portrait of a Lady*. To which Mary added on that same scrap of paper: "I don't think you can have both."

Mary tucked this scrap of writing inside an unsealed envelope in her mostly empty desk drawer.

Mary invented a type of dance that is one of continual expansion until it dissolves in one's mouth.

THE HEART IS A SAFE PLACE / ESPECIALLY IF IT BELONGS TO A BELOVED SISTER

Mary is sitting alone in the Point Lobos bungalow: which still lies in her imagination as a muscle shell writ large—its outer shell of rough bearded cedar, stained dark blue—its smooth edges, painted glossy black—its interior of rainbowy angel's fingernail hidden.

Eliza will be coming home soon. Eliza is out with their black Newfoundland with a snow-white chest, Eugenie, for a run on the beach. Eliza will sit in the empty chair. Eugenie, named for the beloved dugong (the giant manatee-like seaweed eater, who touched the hearts of Mary and her father at Steinhart Aquarium) will put her heavy head on Mary's lap with a heavy sigh. Eliza will drink with Mary, the red wine from Mendocino, as blue as Homer's wine-dark sea. On the table is a small abalone shell: a gift from Eliza. Its interior lined, also, with precious rainbowy angel's fingernail.

With her finger, Mary probes the open holes near the abalone shell's outer edge. And then she traces the older holes that sealed up as the abalone grew. When Mary remembers how they are facing extinction because of pollution and overfishing, her heart sinks.

The door opens gently. Mary looks up. It's not Eliza and Eugenie. It's Melody. She is carrying a heavy case. Inside is a Kodak Super 8 film projector.

The first performance of *Caul* was performed by Mary alone with the sea. *Caul* emerged from the secluded cave that Mary found on a day when the tide was low, was unusually low.

"Keep your body low," Merce would always call out in class.

Later, *Caul* would be quietly danced over the years in San Francisco, Berkeley, and Los Angeles. On small stages. On uninhabited beaches. Even on Anna Halprin's deck.

No photography.

No filming.

But one day in 1964 in the glow of *Caul*'s newness—Melody stumbled upon Mary practicing *Caul* on the beach, facing the sea, with her back turned to the world. It was an early foggy Saturday morning. Melody had come to the beach with her little Super 8. She had come with the intention of filming she did not know what.

Finding Mary dancing *Caul* was serendipitous.

Mary never saw Melody. Never knew she was there.

This secret was Melody's alone.

For the brief three minutes and twenty seconds' length of the Super 8 film, Melody caught Mary somewhere in the middle of *Caul*. That was enough.

For most of her life, Mary never knew about this clandestine filming. Melody was afraid to tell her.

And then, one day, not so long ago, that day is today—Melody (with her wavy white hair styled neatly in a bun with a silvery hairpin) sits down at the little table that Mary is already sitting at. Melody has something to give Mary. The hollows of Melody's eyes are deep and darksome with worry. But within these hollows, her eyes give way to sky lupines plucked for Mary. Looking at Mary very earnestly, with the sky lupines of her eyes, Melody pleads: "Don't be angry."

Melody places the canister on the table and tells Mary what it contains and how the film came to be.

With barely a pause, Mary responds emphatically:

"Okay, Melody, let's watch it. Let's do it. Let's get it done."

Melody goes into the living room with the equipment and sets up the film projector. Mary remains silent and still at the little table while she peers in through the open wall, watching Melody. When the film is ready to be screened, Melody walks over to Mary and takes her by the hand. Mary is clearly nervous, even a little fearful.

Mary stands up slowly and obediently follows her older sister, who is only ten months her senior.

For three minutes and twenty seconds Mary and Melody watch the silent film on the clean uneven white wall in the living room. The silence of the movie gives way to a mixture of sounds—the mechani-

cal hum and clattering of the film running through the projector—the crashes of the waves, muffled and softened by the bungalow's enclosure of our viewers and its distance from the seashore—and their breathing, Mary's more labored than Melody. While Melody watched Mary watching herself watch the sea—Melody felt herself to be . . .

—of the film
—of Mary
—of the sea
—of water in water

Melody had kept the film hidden under her heart.
The heart is a safe place.
Especially if it belongs to a beloved sister.

AS SHE FINGERS THE BREATH HOLES OF THE ABALONE SHELL AGAIN

As the film closes, Melody stays seated in Mother's Mission-style rocker. Mary remains in Father's comfortable overstuffed chair, which Mother reupholstered in a Sanganeri cotton print of blue elephants. Father bought the fabric in Jaipur, known as the "Pink City" of India. (Jaipur was first painted dusty pink to welcome Queen Victoria's husband, Prince Albert, and the practice of painting the city pink still lives on.)

Sitting in the blue elephant chair, Mary is dreamy-tired. She gently opens her mouth. Perhaps she is dreaming of a kiss of apple pie with cinnamon—a kiss of cornbread with honey—a kiss of Mother's samosa, filled with potatoes, green peas, fennel, garam masala, ginger, which has been made with pride for Father, to remind him of his trips to Jodhpur—a kiss of San Francisco sourdough bread with unsalted butter—a kiss of artichoke leaf dipped in mayonnaise—a kiss of bubbly Coca-Cola.

It is not long before Eliza returns from her walk. Eliza's entrance with the bumbling Eugenie startles the half-awake Mary. But she is so happy to see Eliza. So happy to see Eugenie. You can see the joy in Mary's eyes. The relief that they are home.

Mary calls Eliza over and tells her the story of the film—all the while trying to pretend that she is angry at Melody for making the film. Although Mary is a little queasy with the thought of Melody keeping a secret from her, she is not angry with her sister.

The three of them watch the film together.

Eliza for the first time.

Mary for the second time, with Eugenie at her feet.

Melody for the tenth time. Melody loves the film.

It leaves the three of them breathless and a little tearful.

Melody gets up to leave. Eliza and Mary stand up to kiss Melody. The Lovers hug Melody without the usual gaiety. It's not that they are

That sense of living one's deepest life underwater . . .

sad. They are simply moved by time, silence and *one's actual apprehension of what it is like to be a woman, the irreconcilable difference of it, that sense of living one's deepest life underwater* . . .

After their goodbyes, Eliza and Mary sit at the table. Eugenie puts her heavy head on Mary's lap with a heavy sigh. The two women drink the red wine from Mendocino, as blue as Homer's wine-dark sea. And eat pistachios with mauve-colored skin and light green flesh. Mary wonders what will happen to the film as she fingers the breath holes of the abalone shell again.

Through the window the rosy pink light of dawn was making its appearance before sunrise. Eliza is just returning from San Francisco. She is helping to hang a retrospective of her work at the de Young Museum in Golden Gate Park. It is her most important show to date. At the opening dancers will move along the walls, close but not too close to Eliza's work, with their backs facing the viewers, keeping their body low. If only Merce could be there.

Eliza still drives. But the Karmann Ghia is long gone. The journey is over two hours. When she gets on Highway 1 and drives along Monterey Bay, her brain feels clean. Nevertheless, she feels a bit woozy. It's her age. Next time she will get her studio assistant to make the journey with her.

Eliza unlocks the door with the old antique skeleton key, as quietly as possible. She opens the door and takes off her shoes. She is surprised that Eugenie has not barked or come to greet her.

Mary must have gone to bed early.

When Eliza enters the bedroom, she gasps quietly, covering her mouth, as if trying not to wake Mary.

The dog's eyes are sleepy but open. Eugenie's eyes plead with Eliza to come closer. Eliza caresses Mary's hair. Eliza holds Mary's slightly blue hand. Eliza feels for a pulse not there. Eliza puts a finger under Mary's nose, testing for her breath, like a mother does with her baby in the middle of the night—not out of crisis, but to prove to herself that her child is alive and breathing.

Mary did not die alone.

She died with Eugenie at her side and Eliza huddled in her heart, like a mollusk in its shell.

And someone turned the moon off.

Eliza and Melody gently eased Mary's ashes into the Pacific near the cave where *Caul* was first danced. Eliza brought along something else in a tiny redwood box—to toss into the Pacific—to make the journey with her lover's ashes—to release Mary from all earthly concerns.

Inside that box was Mary's caul.

When Melody and Eliza returned to the bungalow, they buried three spirit objects under a birch tree in the garden: the film in its canister, a near-empty bottle of Climate, and a small jar of honey. The honey was a gift from Mr. Larkin's granddaughter Sylvia. Ever since her grandfather died, Sylvia has been keeping the hives alive.

On the surface of the rich soil covering the silence of film, the smell of Monterey cypress, the sweetness of honey—Melody and Eliza spell out M-A-R-Y, with unremarkable shells, bedraggled barnacles, and smooth gray pebbles.

It would not take long for the letters of M-A-R-Y to be swallowed by the earth.

To disappear.

Afternoon. Lying in bed upstairs, Eliza's head is half-buried in the softness of an old feather pillow. Her freshly bathed body takes comfort in the softness of the well-worn, nearly threadbare, well-washed sheets, dried on the clothesline outdoors. The birch trees are lit by the late afternoon sun: their arms reach up to the late afternoon—sighing their white-bark voices up into the white clouds. Peering in at Eliza, one birch branch scritch-scratches at the window of the cool bungalow. Eliza pays no attention to this. She is not awake. Yet she is not asleep. She is falling asleep. Soporific, soft, peaceful: limp as a sleeping cat.

Moon winks.
Moon thoughts.
Someone has turned the moon back on.
The moon hangs light and low against a background of gray blue.
Rock paper scissors.
The paper-lantern moon has found Eliza on the blue-marble earth.
O light of the moon.
The moon is light and can shine bright on a day like today.
The moon weighs eighty times less than Earth.
Light.
Weight.
Eliza is waiting for a telephone call that she does not know is coming.
To love is to wait.

> As Sleigh Bells seem in summer
> Or Bees, at Christmas show
> —Emily Dickinson

The old rotary phone softly purrs a ring.
Like silent speech.
Lifting the phone to her ear, Eliza sleepily says "Hello?"
"Hello, my brave cyclamen."

Yes, it is Mary.

Mary calling from that place where the moon stretches the round earth into a slight oval. From that oceanic place that once knocked out her breath, with the big, crushing waves until it was finished with her.

Mary is alive with the Pacific.

Like the glimmering light of a jellyfish washed up on the beach.

Like swordfish drizzled with butter and plenty of squeezed lemon eaten on her tenth birthday at Alioto's restaurant, with Mother and Father and Melody too: perched high on the San Francisco wharf.

Like the whiff of Mary's two-piece navy-blue bathing suit the summer of her eighth birthday, with its short white pleated skirt (part salt, part mildew, part Tide laundry detergent, part girl, part Pacific Ocean).

Like the surprise of finding a sea anemone in a tidepool, the size and color of a green chrysanthemum: at first fluorescing then closing unexpectedly.

Like finding sand dollars in the wet sand.

Like giant kelp wrapping around your ankles — treasuring your fingertips — snagging you unawares.

Sticky.

Wet.

Prickly.

Ribbons of underwater crêpe flypaper.

Like heat from the rays of the sun while lying naked on the beach: eyes closed; ears open and filled with the sound of the sea.

Like the arms of a lone windswept Monterey cypress atop a rocky cliff at Land's End in Golden Gate Park reaching out to the sea.

And from different worlds Mary and Eliza laugh and talk.

The ivory-colored handset of the telephone, like a smooth conch shell, fills Eliza's ear with Mary's childish voice.

Like sardines bolting in and out of the waves.

The lovely long fingers of Eliza's right hand swim in the air before her — catching each and every one of Mary's shimmering words.

In the background, a quiet static, like susurrant murmurs of the sea.

All the while, Eliza's left hand holds onto the magical conch shell.

The two women float.

Like the world has no gravity.

Like the world was a moon.

Together Eliza and Mary live on and on.

Like the sea.

AFTERWOR(L)D

I was not there to see Mary kick, extend, curl up, take a bow, and take that astonishing turn in preparation for her exit from the womb into this world.

But I remember it.

I remember finding abalone shells. I loved the small ones, which were not so small, were still as big as my mother's hand. I traced my fingers through their breath holes.

I was a child.

I remember being a child.

I remember eating abalone, as a child. I remember their beautiful shells lined with precious rainbowy angel's fingernail. Iridescent. Pearlized aqua-blue, turquoise-blue, toothpaste blue, buttermint green, gray, white, violet-pink, carnation pink. They are facing extinction. Exceedingly rare to find.

The decline of the kelp forest.

The warming ocean.

As if in a throat dance choreographed by Simone Forti, the abalone I taste in memory is salty, like the sea, but strangely sweet. And from it I am delivered to a country far away. A far sea moves in my ear.

ARE WE

extinct yet...

I grew up in Northern California, with the Pacific Ocean at my bare feet in the wet sand of beaches: where sand dollars are easy to find. I had to be careful not to step on washed-up jellyfish. Swimming in the freezing water, I felt prickly, slimy kelp around my ankles, toes, at the tips of my fingers, even on my inner thighs. I felt like I was being touched by the dead. Although I would not have expressed it that way back then.

Mary is cold ocean, Monterey cypress, giant sequoias, abalone,

Thecosomata, Haight-Ashbury, César Chávez, Sierra Mountains, the summer of free love.

Mary is in my throat, my urine, my heat, my madness, my sleep, my me, my writing tense.

I was not there to see Mary Glass born *en caul*, still in her amniotic sac (the theater of her first dance).

But I remember it.

When Mary's ashes were gently eased into the sea, near the cave where her signature dance *Caul* was first performed, Eliza (the love of her life), brought along a small redwood box. Inside that box was Mary's caul.

I wanted to peep inside, but I couldn't.

I remember the desire.

I remember Eliza tossing the small redwood box into the sea along with Mary's ashes.

I will never forget that Mary's father, Theo, read André Breton's startling erotic surreal poem "Free Union" to her mother, Henrietta, during their wedding ceremony—with those resting places for sea snails, the sex of algae, the sex of an iris, a mine, a platypus, the thighs of a skiff. At my wedding, my husband read this poem to me as well. I doubt that anyone remembers Breton's poem from my wedding. But I do.

As a child, I (too), was taken to see the giant sequoia named Wawona in Yosemite's Mariposa Grove. "Wawona" is believed to come from the onomatopoetic call of the owl, the guardian sprit of the sequoia, in the Miwok tongue.

I (too) was shocked by the enormous tunnel that was cut through Wawona's trunk in 1881 for horse-drawn carriages, and later Volkswagens. I thought it was sacrilegious, although I would not have used that word back then. Seeing the cars, I thought about the tree suffering from the smog, which back then was thickly visible, not toxic-invisible like today.

The tree fell down and died in 1969. She was 2,100 years old.

No photo of me with Wawona. I might have refused a picture, like Mary.

I can't remember.

However, there is a photograph of me standing to the side of another giant sequoia in California, with a drive-through tunnel: the still-standing Chandelier Tree. I was afraid to go inside its black hole. I thought about its hidden rings of time, which I had learned about in school.

The sea is a mouth that speaks in waves.

The sea has no choice but to swallow the waste we throw into her — like the cars, batteries, and forks with bent tines that were thrown off the coastline of Fort Bragg. Over time the dumping was outlawed. Over time the sea regurgitated its trash, like reparative words, often into beautiful syllables—like the ruby-colored, sea-beaten hearts of the taillights of automobiles. Today this area of coastline is known as Glass Beach. It draws scavengers, like me, for its garbage.

This visible waste is nothing in comparison to invisible microplastics and forever chemicals.

Invisible carbon-dioxide brings us warm Decembers.

Mary, Melody, and Aaron collected their treasures on an Indian Summer day.

When I was a child, I welcomed those unusual Indian Summer days of October or November. They seemed hopeful, like an endless summer.

With global warming, warm Decembers and Indian Summers are alarming.

Terrifying.

Mary's perfume made from the essential oil of Monterey cypress is called Climate. She keeps it in an old pharmacy bottle of pale-yellow

glass, frozen sunshine, that was tossed and turned by the Pacific before Mary's mother found it.

If you cannot see Mary, perhaps you can smell her.
 Olfactory memory: involuntary, Proustian, startling, profound.
 Remembering Mary.
 Before she is extinct.
 Remembering dance.
 Before it is extinct.
 The poet Jorie Graham, who may or may not remember Mary Glass, understands extinction, memory, and imagination as inseparable.
 Extinction means the end of memory.
 Extinction means the end of imagination.
 If there is no one to remember what is gone, then that's the end of imagination as well.

In Graham's book of poetry *To 2040*, the raven comes in to the extinct world to the writer's desk—the writer at her desk can imagine the raven on her writing paper—because she has seen a raven. You need to *see* to remember and in turn imagine. (Here, seeingness must be in an expanded field of touch, smell, sound, movement.)
 The writer of *2040* remembers an extinct bird.

> *. . . Is this a real*
> *encounter I ask. Of the old*
> *kind. When there were*
> *ravens. No*
> *says the light. You*
> *are barely here. The*
> *raven left a*
>
> *long time ago . . .*

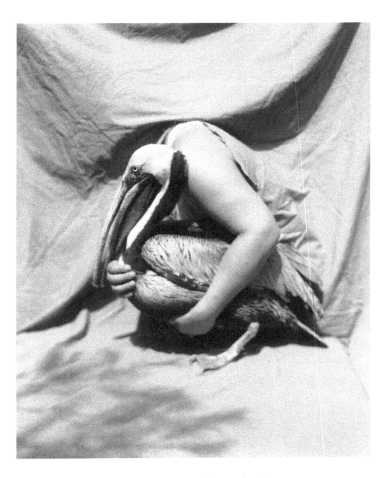

We need to remember extinction
in order to imagine our way out of it.

The writer of *Like the Sea* remembers an extinct dance.
The writer of *Like the Sea* remembers an extinct dancer.
No photo.
No voice.
Only a buried bit of Super 8 film.

Melody's movie camera caught Mary somewhere in the middle of dancing *Caul*, without Mary seeing her. I want you to remember those brief three minutes and twenty seconds of Super 8 film. You have *seen* it.

After Mary's death, Eliza and Melody buried three spirit objects under a birch tree in the garden: the film in its canister, a near-empty bottle of Climate, and a small jar of honey. The honey was a gift from Mr. Larkin's granddaughter Sylvia. Ever since her grandfather died, Sylvia has been keeping the hives alive.

On the surface of the rich soil covering the silence of film, the smell of Monterey cypress, the sweetness of honey—Melody and Eliza spell out M-A-R-Y, with unremarkable shells, bedraggled barnacles, and smooth gray pebbles.

It would not take long for the letters of M-A-R-Y to be swallowed by the earth.

To disappear.

I remember.

I hold on to a Brown Pelican, threatened by extinction. That is what Mary told me to do.

We need to remember extinction in order to imagine our way out of it.

ACKNOWLEDGMENTS

Thank you, Esther Teichmann, for your photographs, which keep me company on the walls of my home. They inspire my words. And thank you for loving the sea so much that one is not surprised to find that you are keeping seaweed in your bathtub. And thank you for teaching me about sisters, through stories of your own, and for being like a sister to me, especially since I have none of my own.

Thank you, Amy Ruth Buchanan, for your brilliant advice on all of my books and for designing a great many of them, including this one. With every book that I make with you at my side, I know that the typeface, the scale, the placement of the images, and a fair amount of serious whimsy will make all other authors envy me.

Hayden White taught me all about *the content of the form*, and he will always be this author's dream.

Thank you, Richard Morrison.

Thank you, Alexandru Ciobanu.

Thank you, Waves, my (also enviable) writing group: Fatema Abdoolcarim (filmmaker, art writer), Alice Butler (art writer), Rebecca Hurst (poet). *Like the Sea* was the second book that I shared with these three women, who are not afraid to tell me the truth. That's true love.

ILLUSTRATION CREDITS

1. Edward Weston, *Nude on Sand, Oceano*, 1936, gelatin silver print. © 2025 Center for Creative Photography, Arizona Board of Regents/Artists Rights Society (ARS), New York, photo Division of Work and Industry, National Museum of American History, Smithsonian Institution.

2. Illustrations by George Stubbs from John Burton, *An Essay towards a Complete New System of Midwifry, Theoretical and Practical* (1751). Wellcome Collection, London (public domain).

3. Matt Neibuhr, *Untitled II (oral side of test) Series: Dendraster excentricus (Western Sand Dollar)*, 2010. © Matt Niebuhr.

4. Edward Weston, *Excusado, Mexico*, 1925, gelatin silver print. © 2025 Center for Creative Photography, Arizona Board of Regents/Artists Rights Society (ARS), New York, photo courtesy of SFMOMA.

5. Baby born "en caul," inside the amniotic sac. Courtesy of Giselinha Corrêa via ViralHog.

6. Anna Halprin teaching her early dance classes for children on the dance deck, screen capture from *Breath Made Visible* (2009, dir. Ruedi Gerber). Courtesy of ZAS Film AG, Zürich.

7. From left: Merce Cunningham, Ruth Beckford and Anna Halprin on the Halprins' dance deck, Kentfield, California, 1957. Photo by Ted Streshinsky. © Ted Streshinsky.

8. Merce Cunningham in his *Changeling* (1957), photo by Richard Rutledge. Courtesy of the Merce Cunningham Trust and the Jerome Robbins Dance Division, New York Public Library.

9. Dugong at the Sydney Aquarium, 2009. Photo Christian Haugen/Flickr (CC BY 2.0 DEED).

10. Ann Halprin, *The Branch*, the Haprins' dance deck, Kentfield, California, c. 1957: Simone Forti (foreground), Ann Halprin, and A. A. Leath. Photo by Warner Jepson. © The Estate of Warner Jepson.

11. Ann Halprin, *The Branch*, the Haprins' dance deck, Kentfield, California, c. 1957: A. A. Leath, Ann Halprin, and Simone Forti. Photo by Warner Jepson. © The Estate of Warner Jepson.

12. Helen Frankenthaler in her studio, photograph by André Emmerich. © 2025 Helen Frankenthaler Foundation, Inc./Artists Rights Society (ARS), New York, photo Archives of American Art, Smithsonian Institution, Washington, DC.

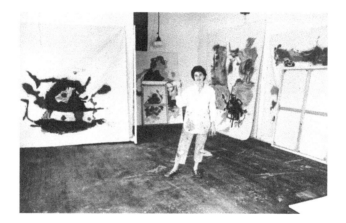

13. Victor Schrager, *Ruby-throated Hummingbird*, 1998, platinum/palladium print. © Victor Schrager 2001.

14. Vija Celmins, *Untitled (Ocean)*, 1977, graphite on acrylic ground and paper. © Vija Celmins, courtesy of Matthew Marks Gallery, New York, photo SFMOMA.

15. Minor White, *Twisted Tree (Cypress Grove Trail, Point Lobos State Park, California)*, May 24, 1951, gelatin silver print. The Minor White Archive, Princeton University Art Museum (Bequest of Minor White), © Trustees of Princeton University.

16. Minor White, *Tom Murphy, San Francisco*, February 1948, gelatin silver print. The Minor White Archive, Princeton University Art Museum (Bequest of Minor White), © Trustees of Princeton University.

17. Carrie Mae Weems, *First Self Portrait*, 1975, gelatin silver print. © Carrie Mae Weems, courtesy of the artist and Gladstone Gallery, New York.

18. Vija Celmins, *Untitled (Ocean)*, 1969, graphite on wove paper prepared with white acrylic paint. © Vija Celmins, courtesy of Matthew Marks Gallery, New York, photo Philadelphia Museum of Art.

19. "Driftwood Village—Community," Sea Ranch, CA. Experiments in Environment Workshop, July 6, 1968. The Work of Lawrence Halprin, The Architectural Archives, University of Pennsylvania.

20. Leonardo da Vinci, *The Burlington House Cartoon (Virgin and Child with Saint Anne and the Infant Saint John the Baptist)*, c. 1499–1500, charcoal (and wash?) heightened with white chalk on paper, mounted on canvas. The National Gallery London, photo Wikimedia Commons (public domain).

21. Marlene Dumas, *Baba (Groot kop)*, 1990, oil on canvas. © Marlene Dumas, courtesy of Zwirner & Wirth and Studio Dumas, photography by Ben Cohen.

22. Louise Bourgeois, *Blue Is the Color of Your Eyes*, 2008, drypoint and ink handcoloring on paper. © 2025 The Easton Foundation/Licensed by VAGA at Artists Rights Society (ARS), New York, photo Moderna Museet, Stockholm.

23. Meghann Riepenhoff, *Littoral Drift #206*, c. 2013, Cyanotype print. © Meghann Riepenhoff, courtesy of Yossi Milo Gallery.

24. William James Warren, [Robert F. Kennedy and César Chávez Celebrate Mass as Chávez Breaks a Twenty-Five Day Fast, Delano, California], 1968, gelatin silver print. The J. Paul Getty Museum, Los Angeles (Gift of William James Warren), © William James Warren.

25. Ron Jude, *Sea Grotto (North)*, from the series *12 Hz*, 2017, printed 2019, Inkjet print. © Ron Jude.

26. Victor Schrager, *Brown Pelican*, 1998, platinum/palladium print. © Victor Schrager 2001.

NOTES

Page 10: *"My wife with the armpits of martens and beech fruit"*
—André Breton, "Free Union," trans. David Antin, in *The Poetry of Surrealism: An Anthology*, ed. Michael Benedikt (Boston: Little, Brown and Co., 1974).

Page 14: *"A blue eye staring back at its beloved blue sky"*
—As Rebecca Solnit writes in her *Field Guide to Getting Lost* (New York: Viking, 2005), Lake Titicaca is "one of those high-altitude lakes, Tahoe, Como, Constance, Atitlán, like blue eyes staring back at the blue sky."

Page 16: *"Childhood is the true meaning of life"*
—Karl Ove Knausgaard, "The Other Side of the Face," *Paris Review*, May 28, 2014.

Page 30: *"Come and kiss me"*
—Christina Rossetti, *Goblin Market: A Tale of Two Sisters* (San Francisco: Chronicle Books).

Page 45: *"Eugenie's captor hauled his prize ashore"*
—"Science: The Original Mermaid," *Time Magazine*, December 5, 1955.

Page 62: *"rainbowy angel's fingernail"*
—Sylvia Plath, "Ocean 1212-W," in *Johnny Panic and the Bible of Dreams: Short Stories, Prose, and Diary Excerpts* (New York: Harper Perennial, 2018).

Page 65: *"Why do starfish always look a little bit drunk?"*
—Anna Selby, *Field Notes* (Sandy, UK: Hazel Press, 2020).

Page 65: *"Cushioned, pulsing, enquiring tendrils of water"*
—Ibid.

Page 66: *"The water has its second thoughts"*
—Ibid.

Page 67: "*sustaining her free-spirited, torso-twisting, arm-swirling gambits*"
—Lewis Segal, "Trisha Brown's Solo Highlights Program," *Los Angeles Times*, May 5, 1997.

Page 82: "*A five-pound steel helmet*"
—My list of what American troops "humped" in Vietnam is taken nearly word for word from Tim O'Brien's *The Things They Carried* (New York: Houghton Mifflin Harcourt, 1990).

Page 83: "*Imagination is a killer*"
—Ibid.

Page 90: "*made of a familiar and poetic substance*"
—Roland Barthes, "Toys," in *Mythologies* (New York: Farrar, Straus & Giroux, 1972).

Page 92: "*her mind to concentrate on anything else but the wait itself*"
—Annie Ernaux, *A Simple Passion* (New York: Seven Stories Press, 2003.)

Page 117: "*flying into the unconscious on a magical carpet*"
—My words are indebted to Marina Warner, *Charmed States and the Arabian Nights* (London: Chatto & Windus, 2001.

Page 119: "*brain feels clean*"
—As Joan Acocella writes in "Object Lesson," *The New Yorker*, August 10 and 17, 2009: "Cunningham's work, like no other, made your brain feel clean. You seemed to be seeing dance for the first time."

Page 119: "*No exit wound to the sky*"
—Ocean Vuong's collection of poems *Night Sky with Exit Wounds* (London: Jonathan Cape, 2017) is echoed here.

Page 121: "*successful idleness*"
—Roland Barthes, "Dare to Be Lazy," in *The Grain of the Voice: Interviews, 1962–1980* (Evanston, IL: Northwestern University Press, 2009).

Page 122
—The movement of *Huddle*—including beast and bee metaphors—reflects the writing of Julia Bryan-Wilson in "Simone Forti Goes to the Zoo," *October* 152 (Spring 2015).

Page 123: *"Yo sé que nunca"*
—"Nunca," Guty Cárdenas (Augusto Alejandro Cárdenas Pinelo), with lyrics by Ricardo López Méndez, 1927.

Page 124: *"a wheel of smiles"*
—Julia Kristeva, "A Wheel of Smiles," in *New Maladies of the Soul* (New York: Columbia University Press, 1995).

Page 129: *"Is innocence just one of the disguises of beauty?"*
—Anne Carson, *The Beauty of the Husband: A Fictional Essay in 29 Tangos* (New York: Vintage Books, 2002).

Page 134: *"as he would take his own child"*
—Taken nearly word for word from Marguerite Duras, *The Lover* (New York: Pantheon Books, 1985).

Page 135: *"Bin in tz'uutz' a chi"*
—From *The Songs of Dzitbalché* in *Ancient American Poets: Inca, Maya & Aztec Poetry*, trans. John Curl (Tempe, AZ: Bilingual Review Press, 2005).

Page 138: *"curved as a dolphin bone held in the sea"*
—Selby, *Field Notes*.

Page 141: *"fugitive cyanotypes are analogies"*
—Meghann Riepenhoff, http://meghannriepenhoff.com. Riepenhoff invented the process of making cyanotypes with the ocean as her collaborator. See her *Littoral Drift + Ecotone* (Santa Fe, NM: Radius Books/Yossi Milo Gallery, 2018). The form and content of Riepenhoff's cyanotypes, made from and of the ocean, are inseparable, in the spirit of Atkins's delicate sea algae. Yet Riepenhoff's cyanotypes are the very opposite of the Victorian naturalist/photographer: they are large and governed by the seraph of the sea of serendipity.

Page 149
—In *Field Notes*, Anna Selby likens blowing kisses to blowing air through a snorkel while being blown back and forth by waves.

Page 161: *"one's actual apprehension of what it is like to be a woman"*
—Joan Didion, "The Women's Movement," in *The White Album* (New York: Farrar, Straus & Giroux, 2009).

Page 167: *"ARE WE / extinct yet"*
 —Jorie Graham, *To 2040* (Port Townsend, WA: Copper Canyon Press, 2023).

Page 170: *"Is this a real / encounter I ask"*
 —Ibid.

CAROL MAVOR is Professor Emeritus of Art History and Visual Studies at the University of Manchester. Her books include *Serendipity: The Afterlife of the Object* (Reaktion Books, 2024) and *Like a Lake: A Story of Uneasy Love and Photography* (Fordham University Press, 2020).

www.ingramcontent.com/pod-product-compliance
Lightning Source LLC
Jackson TN
JSHW070145260425
83343JS00007B/10